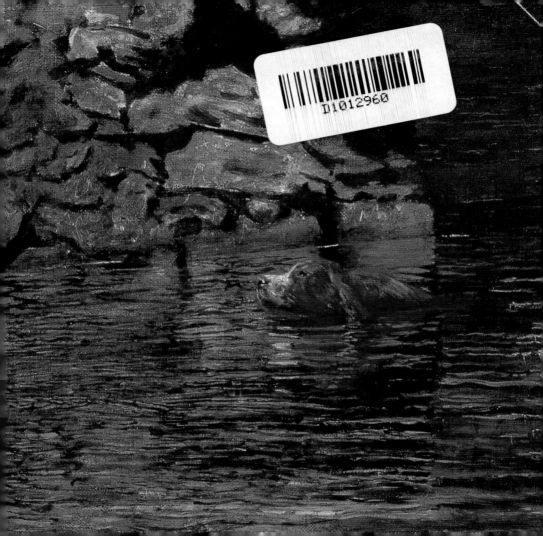

THE ESSENTIAL ™

Thomas Eakins

BY ALICE A. CARTER

THE WONDERLAND PRESS

Harry N. Abrams, Inc., Publishers

THE **WONDERLAND**
 PRESS

The Essential™ is a trademark
of The Wonderland Press, New York
The Essential™ series has been created by The Wonderland Press

Series Producer: John Campbell
Series Editor: Harriet Whelchel
Series Design: The Wonderland Press

Library of Congress Catalog Card Number: 2001087912
ISBN 0-8109-5830-9 (Harry N. Abrams, Inc.)

On the endpapers: Detail of *Swimming.* c. 1883–85. Amon Carter Museum, Fort Worth, Texas

All works are oil on canvas unless otherwise noted

Printed and bound in Hong Kong

Harry N. Abrams, Inc.
100 Fifth Avenue
New York, NY 10011
www.abramsbooks.com

Contents

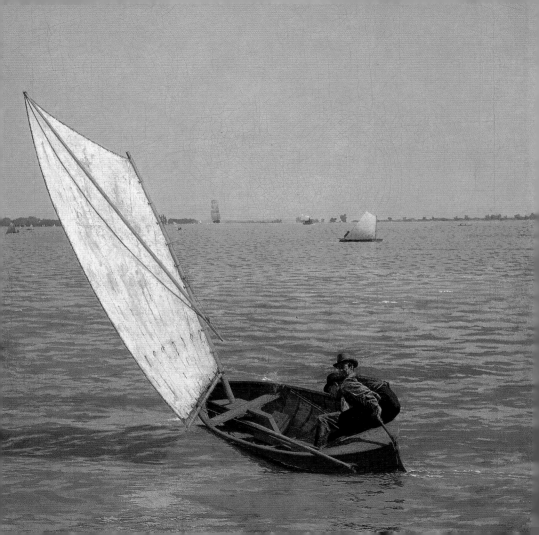

An unknown Great

Ever hear of the strangely underappreciated **Thomas Cowperthwait Eakins** (1844–1916)? Odds are that few of your friends or family would recognize his name or could identify his paintings. Yet the art world considers him one of America's greatest artists. A gifted sculptor, innovative photographer, controversial teacher, and extraordinary painter, he produced more than 500 paintings and drawings throughout a 40-year career.

Why is it that almost no one has heard of him?

- During his lifetime, Eakins's commitment to unadorned realism (sometimes called *naturalism*) was radical. Most critics either maligned or ignored his work.

- Brusque, uncompromising, and unconventional, Eakins found himself engulfed in both personal and professional scandals that divided his family and alienated his colleagues.

- His unorthodox teaching methods and questionable behavior at the Pennsylvania Academy of the Fine Arts (often shortened to PAFA)—where he was director from 1882 to 1886—cost him his job and made him an outcast in the polite society of Philadelphia.

Eakins family home at 1729 Mount Vernon Street, Philadelphia

- He sold very few paintings, and the ones he gave away were often considered worthless, consigned to closets or attics, lost, or destroyed. When he died in 1916, the bulk of his work was still in the Philadelphia home where he had lived for almost 60 years.

- The art world's, and the public's, enthusiasm for Impressionism, and the introduction of Post-Impressionism, Cubism, and Fauvism at the Armory Show in 1913, made Eakins's representational paintings seem outdated.

Sound Byte:

"If a man's fat, make him fat. If a man's thin, make him thin. If a man's short, make him short. If a man's long, make him long."

—THOMAS EAKINS, in a lecture to students at The Pennsylvania Academy of the Fine Arts, c. 1880

Art without Artifice

In the aftermath of Impressionism and all of the *-isms* that followed in the art world (Post-Impressionism, Abstract Expressionism, Modernism, and Post-Modernism), Eakins's extraordinarily skillful canvases seem conservative and were not well received in the late 19th century. In part, this was because in the Victorian era, people loved art that inspired them and enhanced their pleasure or perceptions of the world. They were not interested in art that imitated the mundane details of nature.

Eakins's naturalistic philosophy went against the taste of his peers. He believed that artists should paint objectively and tolerate no embellishments. In 1881, critic Mariana Griswold Van Rensselaer noted that Thomas Eakins was "the most devoted [of all American artists] to the actual life about him, the most given to recording it without gloss or alteration." The fact that Eakins's works included "homely figures with

FYI: **Will the Real Thomas Eakins Please Stand Up?**—What did Thomas Eakins look like? No need to wonder. Nude photographs of the artist show all 5'9" of him—back, side, and front. What did the photos miss? Eakins had brown eyes, black hair, an olive complexion, and for someone with a sturdy, athletic physique, an incongruously high voice.

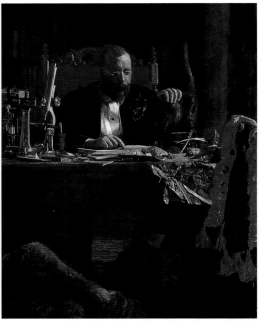

*Professor Benjamin
Howard Rand*. 1874
60 x 48"
(152.4 x 121.9 cm)

ugly clothes" troubled Mrs. Van Rensselaer and almost everyone else who saw his art during the painter's lifetime.

Art Stars

In the 1870s, near the beginning of Eakins's career, the huge romanticized panoramas of such Hudson River School painters as **Albert Bierstadt** (1830–1902) and **Frederic Church** (1826–1900) were immensely popular and generally revered. The post–Civil War generation admired the paintings of rural country life by **Eastman Johnson** (1824–1906). In this era of unprecedented urban growth, they liked his tendency to look back with nostalgia to less complex times.

Portraits were fashionable with American patrons, and several of Eakins's contemporaries enjoyed successful careers as portrait painters. Chief among them were two distinguished American expatriates, **James Abbott McNeill Whistler** (1834–1903)—

most famous for the painting of his mother—and **John Singer Sargent** (1856–1925), whose flattering portraits were prized by wealthy patrons. Both subscribed to the fashionable doctrine of *art for art's sake*, a belief that great art should transcend the tedious realities of everyday life and not attempt to replicate them—that art should be appreciated for its own sake, not for any particular message or innovative technique. Fashionable doctrines did not interest Eakins, who despised any kind of artistic convention. What did interest him was the magnificence of nature—the quality of light and the beauty of the human body. The "big" artist, he once wrote, "keeps a sharp eye on Nature and steals her tools."

A few other 19th-century American painters shared Eakins's passion for realism, and forged their own course. The most famous was **Winslow Homer** (1836–1910), whose dedication to naturalism Eakins admired. Like Eakins, Homer had a distinctly American vision that reflected life as he observed it around him. Unlike Eakins's work, that of Homer showed touches of romanticism. Some of his best-known canvases depict the compelling story of humans struggling with the relentless power of the ocean. These seascapes appealed to patrons who embraced the Darwinian vision of nature as a battleground and who viewed the stylized Hudson River School landscapes with increasing cynicism.

Although Eakins was never able to support himself by selling his paintings, some of the more popular artists of his generation succeeded in

selling their works for large fees to American patrons. At an auction in 1876, Homer's *Prisoners from the Front* fetched $1,800, a princely sum at the time. Eastman Johnston sold two paintings, one for $2,375 and another for $1,000, and the gavel went down on Frederic Church's huge landscape, *Niagara Falls*, at an impressive $12,000.

Just the facts!

In contrast to those of his more successful contemporaries, Eakins's landscapes documented local scenery with **unsentimental candor.** His portraits were similarly accurate. Friends and clients, who commonly devoted months to sitting for an Eakins portrait, were not happy to see their physical deficiencies meticulously catalogued and committed to canvas. When someone asked artist **Edwin Austin Abbey** (1852–1911) why he had never asked Eakins to paint his portrait, Abbey replied, "For the reason that he would bring out all those traits of my character I have been trying to conceal from the public for years."

This allegiance to absolute objectivity would cost Eakins dearly throughout his career, beginning with his first portrait commission. In 1877, the Union League of Philadelphia offered to pay $400 for a likeness of newly elected **President Rutherford B. Hayes** (1822–1893)—a big break for the struggling 33-year-old artist. Although Hayes posed only briefly, Eakins created an effective, if unusual, portrait. Reviewer William Clark described it in the *Evening Telegraph*: "There is certainly

nothing of the mock-heroic in this representation of the President in his old alpaca office coat, with the stump of a lead pencil in his fingers, and with his sunburned face glistening with summer perspiration."

Unfortunately, the members of the Union League thought the ruddy portrait made the president (a staunch teetotaler) look drunk. The painting was removed from the wall and sent to the president with the following note. "I fear when you receive it, Mrs. Hayes will banish it to the rubbish room." No one knows whether Mrs. Hayes put the canvas out with the trash, but the fact is the painting hasn't been seen for more than 100 years. So take a look in the attic. You may be the proud owner of the lost Eakins!

Eakins Remembered

So now that we've seen why Eakins was forgotten, why bother remembering him? Thomas Eakins was a technically brilliant and courageous artist who evoked an honest portrait of the Gilded Age free from the Victorian tendency to moralize or sentimentalize. His knowledge of mathematics, perspective, anatomy, and photography enabled him to abandon long-held artistic conventions in favor of a scientific method that minimized distortion and ensured a degree of anatomic mastery seldom seen since the days of **Leonardo da Vinci** (1452–1519). During Eakins's lifetime, even his harshest critics acknowledged both his originality and his extraordinary skill in documenting without decorating. (Not that that stopped them from criticizing.)

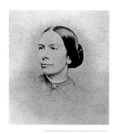

Carte-de-visite
portrait of Caroline
Cowperthwait
Eakins. c. 1860
Albumen print by
Edward Morgan
2 $\frac{7}{16}$ x 3 $\frac{11}{16}$"
(6.02 x 8.94 cm)

Thoroughly modern

The ability to see what *is,* instead of what *ought* to be, is one of the characteristics of Modernism. Although at first glance it is not easy to see what Eakins's meticulously calculated canvases have in common with the innovation of 20th-century art, his work forms a vital link to the revolution that transformed the focus of American painting from refinement to rebellion. Like the Modernists, Eakins had a fascination with invention and discovery. An ardent admirer of scientists and physicians, he sought them out as subjects for his portraits and depicted them with characteristic realism. If you look at his two great master-pieces, *The Gross Clinic* (on pages 42–43) and *The Agnew Clinic* (on pages 88–89), with their blood-soaked depictions of surgery, you'll see why he is linked to subsequent avant-garde movements intended to push the boundaries of what is acceptable in art. Let's see where it all began.

Family Ties

And so the story begins: When you begin to learn about Thomas Eakins's life, you'll see why he never volunteered much biographical informa-tion. Much of his personal history invites speculation if not outright censure. Nevertheless, this complex and troubled man began his life in a conventional, loving family.

Thomas Eakins was born on July 25, 1844, in Philadelphia, Pennsylvania, the first-born child of **Caroline Cowperthwait Eakins** and **Benjamin Eakins**, a well-liked teacher of penmanship at Friends' Central School. His father, a talented calligraphist, supplemented his salary by lettering certificates, diplomas, and legal documents in elegant Spencerian script, a style of florid penmanship popularized in the mid-19th century by calligrapher Platt Rogers Spencer. Benjamin was prudent with his investments and the family lived comfortably. Thomas's sister **Frances** was born in 1848, when the future artist was four years old. By the time he turned nine, their sister **Margaret** was born.

Benjamin Eakins
c. 1845
Daguerreotype

Sound Byte:

"I was born July 25, 1844. My father's father was from the north of Ireland, of the Scotch-Irish. On my mother's side, my blood is English and Hollandish. I was a pupil of [painter Jean-Léon] Gérôme (also of Bonnat and of Dumont, sculptor). I have taught in life classes, and lectured on anatomy continuously since 1873. I have painted many pictures and done a little sculpture. For the public I believe my life is all in my work.
Yours Truly,
Thomas Eakins"

—Thomas Eakins, answer to a request
for biographical information, 1893

Thomas Eakins and his sister
Frances ("Fanny"). c. 1850
Salt print by O. H. Willard
hand-colored

Eakins produced some truly astounding drawings while he was a student at Central High School. By the age of 16, he had mastered difficult problems in perspective and value that would confound many professional artists. At home, he was tutored by his father and wrote with the graceful hand of an accomplished calligrapher. By all accounts, mild-mannered Benjamin Eakins and his brash young son were unusually close. Both loved the outdoors and spent time together on Philadelphia's Schuylkill and Delaware Rivers, skating in the winter and swimming, sailing, and hunting in the summer.

Tom graduated from Central High School on July 11, 1861. The Civil War had been raging since April, but Eakins did not enlist in the Union Army. Instead, his father set him up helping in the family business—teaching calligraphy and inscribing documents. With a bravura that would become his hallmark, he applied for a job as an instructor of art and penmanship at his alma mater, Central High School, less than a year after his graduation. Not surprisingly, the 18-year-old was passed over in favor of an older artist. Undaunted, young Eakins decided to forgo teaching and returned to the classroom as a student. In 1862, he enrolled in the Pennsylvania Academy of the Fine Arts in Philadelphia.

High School
Graduation
Photographs of
Thomas Eakins
(left) and William
Sartain (right)
1861. Salt print

Pennsylvania Academy of the
Fine Arts, Philadelphia

Enter the Sartains

At the Academy, he attended life-drawing sessions, registered for anatomy lectures, and made drawings from the school's collection of antique casts. There were no paid teachers or formal instruction, so Eakins probably relied on the more experienced students for advice and criticism. He also benefited from the guidance of two artists who were friends of his father: **George W. Holmes** (c. 1812–1895), a local landscape painter and art teacher, and **John Sartain** (1808–1897), an internationally renowned engraver. Young Eakins went out painting with Holmes, and he came to know the Sartain family well. The Sartains—father, John, and his children **Samuel, Henry, Emily, William**, and **Harriet**—were one of the most illustrious and influential families in

the history of American art. As printmakers, artists, and educators, they played a central part in both the local and national art communities. William Sartain was Thomas Eakins's classmate, first at Central High School and then at the Academy. Bill's accomplished sister Emily, three years older than her brother and also an Academy student, admired young Tom. The two became close friends.

The few drawings that survive from Thomas Eakins's years as a student at the Academy are impressive. In just four years, he had mastered the discipline of perspective and of life drawing. His charcoal studies showed a mature understanding of form and anatomy. But his knowledge of anatomy was not merely the result of some latent genius:

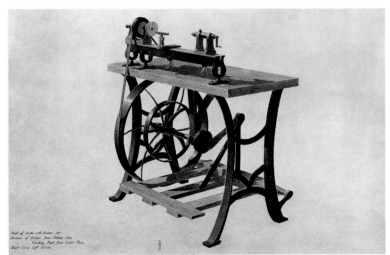

Perspective Drawing of a Lathe owned by Eakins's Father (completed while Eakins was in high school). 1860 Pen & ink and watercolor on paper. 16 $^5/_{16}$ x 22" (41.4 x 55.9 cm)

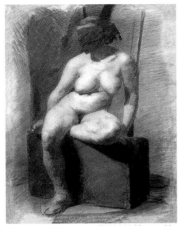

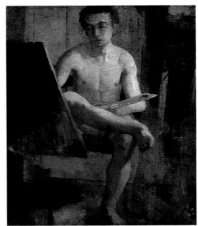

FAR LEFT
*Nude Woman Seated,
Wearing a Mask*
c. 1866. Charcoal
24 x 18"
(58.8 x 44.1 cm)

LEFT
Charles L. Fussell
Young Art Student
(Sketch of Thomas
Eakins). c. 1865
Oil on paper
15 x 12 ¾"
(36.75 x 31.24 cm)

The young artist had an abiding interest in human physiology and he supplemented his art education by attending the rigorous anatomy classes required of the students at Philadelphia's Jefferson Medical College.

Sound Byte:
"I am leaving my good father and my sweet mother, and shall go to some strange place, certainly not England, but much stranger still, where there are no relatives, friends, or friends of friends; and I go alone."
—THOMAS EAKINS, writing to Emily Sartain,
September 18, 1866

17

THE PENNSYLVANIA
ACADEMY OF THE FINE ARTS

The effort to establish a Philadelphia art academy began as early as 1791, when painter **Charles Willson Peale** (1741–1827), sculptor **William Rush** (1756–1833), and Corsican sculptor **Giuseppe Ceracchi** (1751–1802) decided to gather a collection of paintings and sculpture and set up a school of art. Their efforts were not productive, and the association of the three artists soon dissolved. However, Charles Willson Peale refused to abandon the idea and in 1794 successfully opened his own academy. The fledgling institution was immediately riddled with problems. Professional models for life drawing classes were nonexistent, so Peale stripped to the waist to pose for his astonished students. Unfortunately, his example did not cause others to cast off Victorian standards of modesty to take their turn on the model stand. Adding to Peale's difficulties was his realization that even the nude statues in his collection offended the public. A cast of the Venus de Medici deemed too risqué to put on display was consigned to a box. The school failed, but Peale continued to dream and plan. He was eventually rewarded for his efforts in 1805 when 71 of Philadelphia's eminent citizens gathered at Independence Hall to charter the acclaimed Pennsylvania Academy of the Fine Arts (known as PAFA).

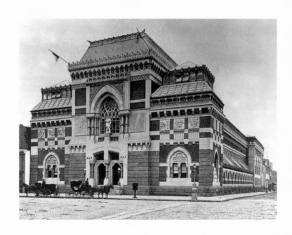

Stranger in Paris

After four years of study, Thomas Eakins realized that his education was incomplete. He could draw, but he could not paint. Frustrated by the lack of professional instruction in the United States, he enlisted the aid of his father to finance his enrollment in the famous École des Beaux-Arts in Paris, France. Eakins was confident that after a few years under the tutelage of one of the École's eminent teachers, he could return home and support himself as a painter. Benjamin Eakins wasn't so sure: "You learn to paint as best you can, Tom. You'll never have to earn your own living."

Tom embarked on his journey with trepidation. He had to leave behind his beloved parents, his sisters Frances and Margaret, now 18 and 13 respectively, and his baby sister, **Caroline** (Caddy), a mere 18 months old. Benjamin Eakins, Tom's friend William Sartain, and William's sister Emily—with whom Tom had a social "understanding" if not an official engagement—went to New York City to see him off. On September 22, 1866, he steamed out of New York harbor bound for adventure. He was 22 years old. On arriving in Paris, Eakins was stunned to discover there were no vacancies at the École. The school had filled its quota of foreigners, and there were four Americans ahead of him, waiting for an opening. Without compunction, Eakins stepped to the front of the line of eager applicants. For a month, he cut a swath through French bureaucracy using a series of impressively lettered empty envelopes and a feigned ignorance of the French language. His assault finally generated

Sound Byte:

"On looking back at my month's work, I have certainly to regret that to get what I wanted I had sometimes to descend to petty deceptions but the end has justified the means and I cannot feel ashamed of them for they were practiced on a hateful set of little vermin, uneducated except in low cunning, who having all their lives perverted what little minds they had, have not left one manly sentiment."

—THOMAS EAKINS, writing to his father
about French bureaucrats in October 1866

Jean-Léon Gérôme
at about 40
Photograph by
Charles Reutlinger

results: He gained admission to the École and the other American applicants sailed in on his wake.

Eakins emerged from his ordeal with a lifelong hatred for bureaucrats and administrators.

An Important Teacher

Eakins knew from the outset that he wanted to study with the great **Jean-Léon Gérôme** (1824–1904). Gérôme was just beginning the fourth year of what would become a 39-year career as a teacher. He was enthusiastic and fair-minded. Eakins was delighted with his teacher, and the more he saw Gérôme, the more the young American liked him. Surprisingly, the volatile Eakins endured the traditional École hazing with good grace: He paid the 20-franc *bienvenue* (welcome) demanded of him by the other students and accepted the fact that, as a newcomer, he must run their

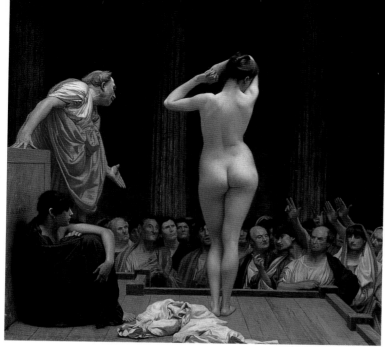

Jean-Léon Gérôme
*A Roman Slave
Market.* c. 1884
25 ¼ x 22 ½"
(61.7 x 55.1 cm)

errands. After surviving the ordeal of being granted admission, Eakins was prepared to endure anything in order to stay with his chosen mentor.

At the age of 42, Gérôme was already famous for his detailed and highly finished canvases of ancient Greece and Rome, as well as his Orientalist works based on frequent travels to the Middle East. His paintings were stylized and sentimental but meticulously researched and accurate

in every possible detail. Gérôme's dedication to the study of anatomy, ethnology, archaeology, architecture, and light struck a chord with Eakins, who had already embarked on a similar course and agreed with his teacher's insistence on rigorous academic training.

Sound Byte:
"It is austere and profound studies that make great painters and sculptors. One lives one's life on this foundation and if it is lacking one will only be mediocre."

—JEAN-LÉON GÉRÔME, advice to students

Fast Forward: For the next three and a half years, Eakins applied himself wholeheartedly to his career.

- He worked hard to improve his drawing, and after five months was allowed to begin painting.

- He supplemented his studies by taking classes with sculptor **Augustin Alexandre Dumont** (1801–1884).

- He frequented the galleries at the Louvre.

- He struggled with his painting and was confounded by color.

- He leased a private studio so he could work on weekends.

- He continued his anatomical studies.

For a young man, Eakins was intolerant, quick to pass judgment, and not especially charitable. Here's a sample of some of the acidic opinions he formed during his sojourn in Europe:

- "Rubens is the nastiest, most vulgar noisy painter that ever lived.... His pictures always put me in mind of chamber pots & I would not be sorry if they were all burnt."

- "The nest of American artists at Rome is an infection. Their aim is to get big prices heavier than those commanded by the greatest artist.... Pickpockets are better principled than such artists, for pickpockets rob from strangers."

- "We meet, of course, crowds of Englishmen. They are great hogs, so different than the French."

Adieu to Emily

In 1869, after three years of elation and optimism tempered by bouts of insomnia, depression, homesickness, and ill health (made worse by his draughty, damp lodgings), Thomas Eakins finally began to feel that his life was on an even keel. Although his romance with Emily Sartain did not survive their separation, he managed to maintain a close friendship with her brother William.

Sound Byte:

"I love sunlight & children & beautiful women & men their heads & hands & almost everything I see & some day I expect to paint them as I see them and even paint some that I remember or imagine [or] make up from old memories of love & light & warmth &c &c."

—THOMAS EAKINS, in a letter
to his father, 1868

In March 1869, William joined Eakins in Paris to share his studio and study with portrait painter **Léon Bonnat** (1833–1922). His friend's arrival lifted Eakins's spirits, but what cheered him most was his own progress as a painter.

Thomas Eakins would never make a living as a painter, but fortunately he had no idea what the future held. Encouraged by his improvement, he skipped a vacation when the École closed at the end of July 1869 and joined William Sartain for a month of private study with Bonnat. Under Bonnat's gentle guidance, his optimism grew until at last Eakins realized that his education was finished. In late fall 1869, Eakins informed his father that he felt as strong as any of Gérôme's pupils and had nothing further to gain by remaining in Paris. Having completed his studies, Eakins assured his family that he'd return to Philadelphia as soon as possible—although, for the time being, he was in no condition to make a winter crossing, having been ill for weeks. Chronic intestinal problems and a persistent cough plagued him. In his damp room, cold draughts blew in under the doors and window sashes and up the chimney, taking any warmth his fire might have provided along with them. He decided to go to Spain and let the sun work its wonders.

BACKTRACK:
HAZING AT THE ÉCOLE
DES BEAUX-ARTS

The hazing Eakins endured on his first day as a student at the École des Beaux-Arts was a tradition in Parisian art academies—and Eakins was lucky. His reception could have been a lot worse. An unsuspecting newcomer was often forced to strip naked and be subjected to the humiliation of having certain of his body parts decorated with Prussian blue paint—a difficult color to remove. A student whose arrogance or apprehension annoyed his compatriots could be tied to a ladder, hung upside down from the rungs, and propped against the École's walls. Victims were sometimes injured, and in 1843 a terrified student died of a heart attack. Where was the teacher when these rituals were enacted? Not in the studio. The masters showed up on only two specified days each week—and on those occasions everyone was on his best behavior.

Thomas Eakins at about 24
c. 1868. Photographed by
Frederick Gutekunst. Silver print
from wet-plate negative
6 $7/8$ x 4 $7/16$" (16.9 x 10.9 cm)

Sunny Spain

Eakins headed for Madrid and the Prado Museum, where at last he found paintings he could truly admire. Three years among the art treasures of France had failed to impress him, but he found his muse in the works of the Spanish masters **José de Ribera** (1591–1652) and **Diego Velázquez** (1599–1660). Their paintings struck him as powerful, honest, and free from the Rubenesque romanticism that he had come to despise. Brimming with enthusiasm, he reported to his father that he had seen "big paintings" in Madrid and that he loved their lack of affectation. Before, when he had looked at other paintings by old masters, he found them "pretty" but lacking in realism. The Spaniards were different.

After several heady days, Eakins set out for Seville. Miraculously restored to health by the warm weather, Eakins was eager to set brush to canvas. The gypsy street entertainers intrigued him, particularly seven-year-old **Carmelita Requeña**, who became the subject of Eakins's first professional painting, *A Street Scene in Seville*. In this ambitious, large work (approximately 4' x 5'), little Carmelita dances in the bright Spanish sunlight accompanied by her parents

on horn and drum. The painting is not entirely successful, since Eakins was still struggling with color and composition, and he called the result "an ordinary sort of picture." Nevertheless, it was the first painting he had ever completed.

Sound Byte:

"One terrible anxiety is off my mind. I will never have to give up painting, for even now I could paint heads good enough to make a living anywhere in America. I hope not to be a drag on you a great while longer."

—Thomas Eakins, in a letter
to his father, June 1869

Home and Hearth

True to his word, when Eakins returned to Paris, he packed up and left for Philadelphia, arriving on July 4, 1870. For the rest of his life, he would speak with great fondness about his three and a half years in Europe, yet he would never go back. Instead, the act of returning to Philadelphia was a symbolic (and literal) act of "going home": Benjamin Eakins had converted the fourth floor of the family residence at 1729 Mount Vernon Street into a studio where father and son could work side-by-side. But Tom craved privacy and worked out a deal with his father where, in return for a nominal fee, he would receive his board, lodging, and the exclusive use of the studio.

American artists of the 19th century looked toward Europe for the inspiration they felt was lacking on their native soil. Young Americans who could afford to travel flocked to the famous art schools in Rome, Düsseldorf, Munich, and Paris to soak up continental sophistication. Those who returned brought back European technical skill, taste, and convention. Some of the best American artists settled in Europe permanently. **Mary Cassatt** (1844–1926), **John Singer Sargent** (1856–1925), and **James Abbott McNeill Whistler** (1834–1903) forged successful careers in Europe. Whistler, who was born in Lowell, Massachusetts, and left his native country at the age of 21 to make his home in England, was not particularly proud of his callow American heritage. "I shall be born when and where I want," he once declared, "and I do not choose to be born in Lowell."

After getting his father to agree to this plan, Thomas Eakins reverted to the role of dutiful son—and why not? Benjamin Eakins had given him carte blanche to do as he pleased. With no immediate worries about supporting himself, he could paint whenever, wherever, and however he chose without having to conform to conventions or please patrons.

A series of small paintings that he made of his sisters and their friends represented an astonishing improvement over his European canvases. Sticking to his convictions, he created work free from artifice. The light, the clothing, the furniture, and the people were depicted just as he found them when he stepped back into the family home. These paintings were precursors to the more ambitious portraits he would tackle a few years later. They bore the hallmarks that set Eakins's portraits apart from the work of his contemporaries.

How to identify an Eakins Portrait

There are distinct patterns and stylistic traits in Eakins's portraits that enable viewers to identify them immediately:

- The subject of the portrait is not painted in a flattering, idealized, or sentimentalized fashion.

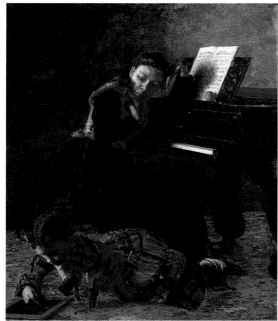

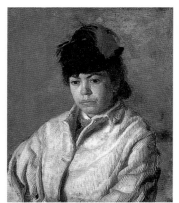

The Brooklyn Museum, New York

Philadelphia Museum of Art. Gift of Mrs. Thomas Eakins
and Miss Mary Adeline Williams

ABOVE
*Portrait of Margaret Eakins in a
Skating Costume.* 1871
24 1/8 x 20 1/8" (61.3 x 51.1 cm)

LEFT
Home Scene. c. 1871
22 x 18 1/4" (53.9 x 44.7 cm)

- The subject rarely looks directly at the viewer and appears to be preoccupied with something more important than posing for the portrait.

- The color in an Eakins portrait is subdued.

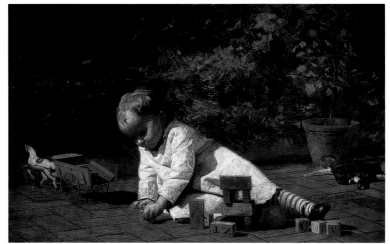

Baby at Play
1876
32 ¼ x 48 ⅜"
(81.9 x 122.8 cm)

National Gallery of Art, Washington, D. C. John Hay Whitney Collection

- The light most often originates from the left side and is focused on the central figure, leaving the background in darkness.

- The sitter is portrayed in everyday clothing and posed in a modest, contemporary setting.

- The hands (when they are included) are painted with as much attention to detail and individuality as the face.

The domestic serenity that Eakins recorded in his paintings belied the reality of the situation at home. Shortly after Eakins's return, his moth-

er, Caroline, fell ill. The exact nature of her ailment is a mystery, but according to her doctor, she suffered from "exhaustion from mania." This odd diagnosis was not uncommon in an era when many health problems were poorly understood and symptoms were often mistaken for diseases. Caroline Cowperthwait Eakins's illness affected the entire family. Because his mother worried whenever Eakins went out in the evening, the young artist who was accustomed to frequenting Parisian cafés and dance halls opted to stay home.

Sound Byte:

"In a big picture, you can see what o'clock it is afternoon or morning and if its hot or cold winter or summer & what kind of people are there & what they are doing & why they are doing it."

—THOMAS EAKINS,
in a letter to his father, 1868

Gilded-Age Macho

When he did go out, Eakins was eager to plunge back into the athletic life he had enjoyed as a boy. Philadelphia's two rivers still held his imagination. The Schuylkill, now flanked on either side by popular rowing clubs, was home to several nationally recognized sculling courses. Eakins was an avid oarsman but not on the level of his high-school

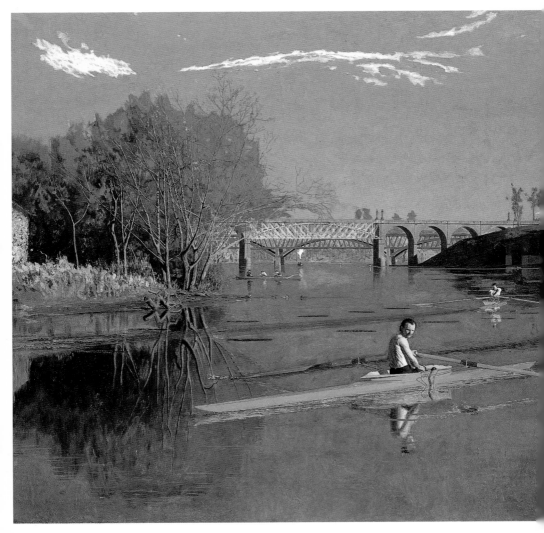

classmate **Max Schmitt** (1842–1900), who had gained celebrity status by winning several highly competitive races.

Boat racing had become a popular spectator sport in Philadelphia, and it was not unusual for contests to attract thousands of enthusiastic fans. In this common city spectacle, Eakins observed the same honest valor he admired in his own family—that is, ordinary people doing their best. He took up his brush and began a series of paintings of his hometown heroes.

Max Schmitt, sculling through the still waters of an autumn afternoon, is the subject of Eakins's first rowing picture, *The Champion Single Sculls*. It is a completely original painting, unprecedented in its attention to realism and lack of artifice. This picture was one of the first works that Eakins exhibited.

The Champion Single Sculls. 1871
32 ¼ x 46 ¼" (81.9 x 117.5 cm)

Nine months after his return from Europe, he submitted the canvas to a show at the Union League of Philadelphia. The reviews were mixed, but not too bad for a 26-year-old artist. The *Philadelphia Evening Bulletin* reviewer noted that the picture held "more than ordinary interest." The artist, he wrote, showed promise of "a conspicuous future." These were prophetic words: Eakins's future would indeed be conspicuous, but for reasons other than the quality of his work.

Caroline Eakins succumbed to her mysterious illness on June 4, 1872. Her son dealt with the tragedy by setting to work with renewed determination. Within a month, he was back at the river, sketchbook in hand. Captivated by the physical prowess of North American single-scull champion, **John Biglin**, Eakins began a series of paintings that depicted John and his brother, **Barney Biglin**, in action. During the next two years, he produced four oils, five watercolors, and numerous drawings and studies of the Biglin brothers.

Eakins's rowing pictures allowed him to flex his artistic muscles by showcasing the skills he had acquired during his intensive training in Paris. No doubt he hoped someone would notice. His portraits of half-clad athletes caught in mid-action became a vehicle for his extraordinary understanding of anatomy. The tilt of the boats and their meticulously researched reflections on the waves gave Eakins a chance to flaunt his mastery of perspective. But while the athletes he painted attracted crowds of admirers, Eakins was unable to interest anyone in purchasing his rowing series.

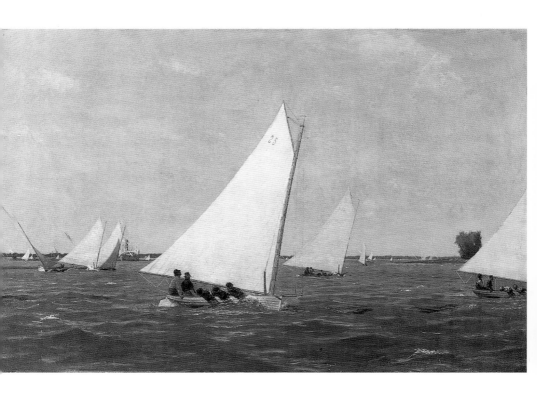

Plagued by doubts

In need of much reassurance, the artist packed up a watercolor of John Biglin and sent it to Gérôme for criticism. Although his former teacher's comments were positive, Eakins was not satisfied. He repainted the picture and sent it back. Gérôme's unqualified praise failed to quell his doubts. Eakins found the Biglin series—a body of work that 100 years later would be hailed as a landmark in American art—clumsy and "wanting in distance & some other qualities." He tried once more, this time painting the Schrieber brothers pulling their pair-oared scull through in a small, glowing composition that combined all he had learned in the past three years. Eakins was convinced that this canvas was as good as any contemporary American painting. In the hope that it would bring him a little spending money, he sent it off to the 1875 exhibition at the National Academy in New York.

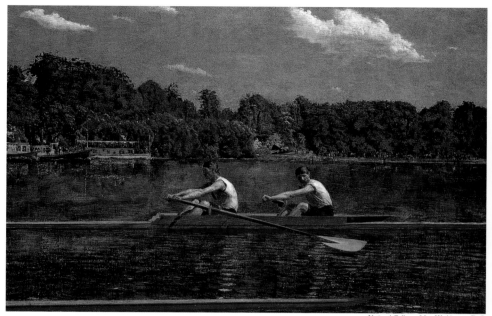

The painting was rejected. At first Eakins wondered if it had arrived on time. When he realized that his entry was simply refused, he was furious and decided that the judges were either ignorant or jealous. The adamant young artist remained convinced that the future would bring him the fame he deserved. Apropos of the rejection he wrote to a friend, "My works are already up to the point where they are worth a good deal and pretty soon the money must come." The money did not come. From 1870 until 1878—a time when he painted some of his greatest masterpieces—Eakins earned a total of $140 from the sale of his paintings.

The Biglin Brothers Racing. 1873–74
24 ⅛ x 36 ⅛"
(61.2 x 91.6 cm)

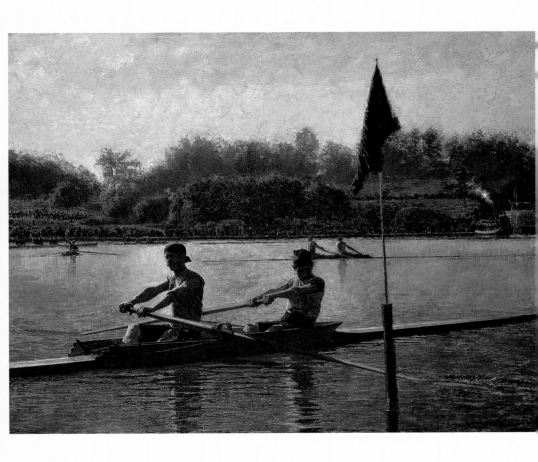

The Turning Point: For this composition, Eakins chose the decisive moment in the five-mile contest. The Biglins (that's John on the right and Barney on the left) have just turned their scull around their blue stake flag and are headed home. The team of Coulter and Cavitt can be seen several lengths back, straining to reach their flag. Both teams are vying for a purse of $2,000.

How: Like Eakins's other rowing paintings, this one was preceded by meticulous drawings that plotted everything from the angle of the oars to the reflections in the water. Eakins began the painting by transferring his detailed technical study to the canvas, underpainting the surface with a layer of dark brown tone, and finally building up his colors with a combination of opaque paint and transparent glazes.

Where's Thomas? Did you notice the tiny figure cheering in the scull near the red stake flag? That's Thomas. He often threw himself into his work—literally. See if you can find him in *The Champion Single Sculls*.

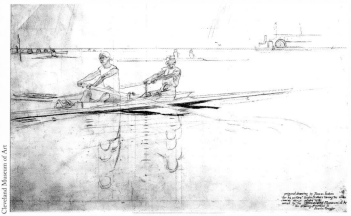

Cleveland Museum of Art

Sketch for
*The Biglin
Brothers Turning
the Stake*. 1873
40 x 60"
(98 x 147 cm)

A study for one of the rowing pictures brought $80 at the 1874 annual show of the American Society of Painters in Water Colors. In 1875, Parisian art dealer Adolphe Goupil sold a small canvas, *Whistling Plover*, for $60 gold.

Quest for Independence

Carte-de-visite
portrait of Frances
("Fanny") Eakins
c. 1868
Photograph by
Frederick Gutekunst
Albumen print
3 $^{15}/_{16}$ x 2 $^{1}/_{2}$"
(9.7 x 6.1 cm)

Pennsylvania Academy of the Fine
Arts, Philadelphia

Tom's yearning for financial independence grew stronger as a result of a series of domestic changes that occurred at this time. In 1872, his sister Frances married Tom's boyhood friend, **William Crowell** (1844–1929). The bride and groom settled into Benjamin Eakins's house at 1729 Mount Vernon Street in Philadelphia, and over the next four years they added three children to the extended family. In 1874, at the age of 30, Tom reinforced the ties between the two families by becoming engaged to William's 23-year-old sister, **Kathrin Crowell** (1851–1879). In contrast to his romance with the dynamic, artistic Emily Sartain, Tom's courtship with Kathrin—a plain girl of no notable accomplishment—might seem odd.

But although rumor has it that Benjamin Eakins engineered the match as an antidote to his son's tendency to carouse, it is likely that Tom was

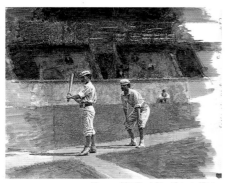

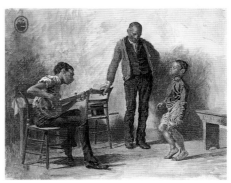

indeed attracted to Ms. Crowell. Two years earlier, in 1872, he had selected Kathrin as the subject of his first major portrait, posing her in the carved wooden armchair that would eventually appear in 12 of his paintings.

Eakins prepared for his nuptials by searching out a theme that might make his canvases more marketable. He painted a series of sailing pictures, experimented with watercolor, tried genre painting, and continued to produce paintings of the people he admired—including African Americans, whom most artists of his time excluded from their works. In 1875, Eakins hit on the idea of painting the celebrated physician Dr. Samuel D. Gross at work in his surgical amphitheater, sure that this theme would draw interest from potential buyers. The resulting canvas became his masterpiece, *The Gross Clinic*.

ABOVE LEFT
Baseball Players Practicing. 1875
Watercolor
$10\,^{7}/_{8}$ x $12\,^{7}/_{8}$"
(27.6 x 32.7 cm)

ABOVE RIGHT
Negro Boy Dancing
1878. Watercolor
on off-white
wove paper
$18\,^{1}/_{16}$ x $22\,^{9}/_{16}$"
(46 x 57.4 cm)

THE GROSS CLINIC

1875. 96 x 78" (243.8 x 198.1 cm)

Jefferson Medical College of Thomas Jefferson University, Philadelphia, Pennsylvania

What: Eakins's fascination with human anatomy led him to Philadelphia's Jefferson Medical College, where he enrolled in Practical Anatomy courses. It was there that he met Dr. Samuel D. Gross, whose commanding presence in the surgical amphitheater inspired Eakins's magnum opus, *The Gross Clinic.*

Docudrama: Painted when Eakins was only 30 years old, *The Gross Clinic* includes more than two dozen portraits and records a complex medical drama with vivid realism. Having completed his incision, Dr. Gross pauses while his assistant, Dr. James M. Barton, probes for a piece of necrotic (i.e., dead) bone in the thigh of his young patient.

Chiaroscuro: The painting is a brilliant study in contrasts: The calm detachment of the surgical team and the objective interest of the medical students are juxtaposed against the vulnerability of the young patient and the agony of his mother who averts her eyes in horror. Eakins sets darkness against light, science against disease, and ignorance against knowledge.

The Verdict: Today art historians see genius in this masterful work that has been called one of the greatest paintings of the 19th century. Unfortunately, when Eakins exhibited his canvas, few reviewers were enthusiastic. Various critics described the painting as " both horrible and disgusting" and "a degradation of Art."

Fun Fact: Perhaps you're wondering why Dr. Gross was operating in his street clothes? In 1875, scientists did not fully understand the relationship between germs and disease, so sterile conditions were not a priority. The important thing was to dress with distinction. Here, Dr. Gross wears his lucky jacket—a garment he called "a veteran of a hundred battles." Did he rush to the dry cleaners after each operation? Apparently not, although the coat must have been cleaned occasionally—perhaps with a coffee/ammonia mixture, or one of turpentine combined with lemon oil.

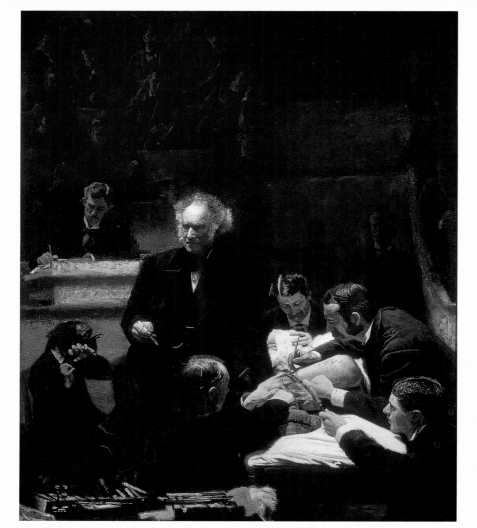

Eakins worked on *The Gross Clinic* for most of the year. The valiant Dr. Gross posed so many times that he finally shouted in exasperation, "Eakins, I wish you were dead!"

The Centennial Exhibition of 1876

Eakins planned to exhibit *The Gross Clinic* at the United States Centennial Exhibition opening in Philadelphia on May 10, 1876, and thereby to secure his place as an American master. All his hopes were pinned to this one large canvas—and why not? Family friend John Sartain was part of the selection committee, and he had already told his daughter (Tom's ex-girlfriend, Emily) how much he liked the painting. Yet *The Gross Clinic* was rejected. The *Philadelphia Evening Telegraph* reported that the blood on Dr. Gross's fingers made some of the committee members sick and, consequently, they harbored grave doubts about exposing the public to so graphic a work. Eakins was sick at heart. But his painting eventually found a place in the Centennial Exhibition—not in the art gallery but in the Army Post Hospital exhibit, where it hung on a wall of a mock hospital ward complete with papier-mâché patients. A friend reported that when Eakins saw it displayed so poorly, he nearly cried.

44

It is impossible not to admire Eakins's stick-to-itive-ness. Like the Phoenix, he rose from the ashes of his disappointment to create yet another painting. Again, he selected a hometown hero as the subject for his new canvas. This time it was **William Rush**, a Philadelphia sculptor who had died more than 50 years earlier and who now teetered on the brink of artistic oblivion. In the composition, entitled *William Rush Carving His Allegorical Figure of the Schuylkill River*, Eakins depicted the sculptor in his studio carving the first public fountain in America while his model, prominent socialite **Louisa Van Uxem,** posed in the nude as a chaperone knitted in the corner.

For all of Eakins's attention to accuracy, *William Rush Carving His Allegorical Figure of the Schuylkill River* was a technical departure for him. It is highly unlikely that Miss Van Uxem stripped naked in Rush's studio, chaperoned or not. Nonetheless, Eakins wished to make the statement that great art could be created only after a detailed, candid study of nature. Analyzing and painting the nude figure was one of his passions; he felt there was nothing more beautiful than the human body. Not only did Eakins hold this conviction in his head and heart, but he actually *lived* it

Philadelphia Museum of Art. Gift of Mrs. Thomas Eakins and Miss Mary Adeline Williams

Study of a Seated Nude Man
1874–76. Charcoal on paper
24 5/16 x 18 1/2" (61.8 x 47 cm)

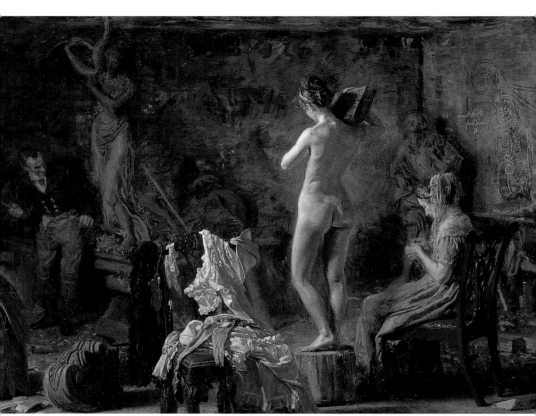

by swimming and sailing stark-naked and shocking his family by appearing in various states of undress at home. Although Eakins was comfortable with nudity, the public did not share his enthusiasm for the unclothed human form.

This was, of course, Victorian America and, in hindsight, it's easy to see that Eakins was headed for trouble. But he plowed ahead and lived the fiction he invented for Rush by persuading an amateur to pose for this painting. The 18-year-old **Anna W. (Nannie) Williams** agreed to be his model in *William Rush Carving* on the condition that she remain anonymous.

Eakins first exhibited the painting in 1878 and the critics responded as they had in the past: While they extolled his technical skill, they lamented his theme and, in particular, grumbled about the naked girl and the way her clothes were tossed to one side, emphasizing her nakedness. But although the canvas failed to launch Eakins's financial success and was

OPPOSITE
Detail of *William Rush Carving His Allegorical Figure of the Schuylkill River.* 1876–77
Oil on canvas on Masonite
20 1/8 x 26 1/8"
(51.1 x 66.4 cm)

FYI: **Nannie cashes in**—Eakins's model for his painting *William Rush Carving His Allegorical Figure of the Schuylkill River*, Miss Anna W. (Nannie) Williams, became one of the most documented women in America, not because she was immortalized by Eakins, but because she posed for another artist, George T. Morgan. In fact, you might own a copy of the Morgan portrait! If you have a silver dollar minted between 1878 and 1904, or one issued in 1921, check it out. That's Nannie's profile right under "E Pluribus Unum."

stored in his studio for the remainder of his life, it succeeded in securing for Rush a permanent place in the canon of American art.

A Genius for Teaching

In 1874, Eakins was invited to teach a life class at the Philadelphia Sketch Club. The school at the Pennsylvania Academy of the Fine Arts had been closed since 1870 during the time when the old building was demolished and a new one erected, so the Sketch Club was taking up the slack. Eakins received no salary, but had the opportunity to do what he liked best—study the human figure. The all-male classes were an immediate success. Such promising artists as **Thomas Anshutz** (1851–1912), who would someday make a name for himself as a painter, enrolled in the course. Eakins taught them all with patience and understanding, even though many of them were not very talented.

Sound Byte:

"To study anatomy out of a book is like learning to paint out of a book. It's a waste of time."

—THOMAS EAKINS, 1879

In 1876, the Academy reopened and the distinctive new building boasted the largest, best-equipped art studios in the United States. Eakins, who knew a good opportunity when he saw it, was anxious to have a role in reestablishing the Academy's classes. Although painter

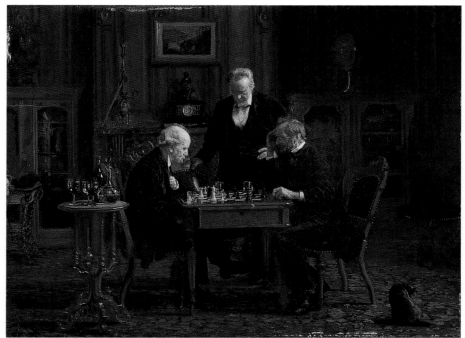

Christian Schuessele (1824–1879) had been the institution's Professor of Art since 1868, he had not weathered the school's six-year hiatus well. At the age of 52, he was afflicted with palsy and paralysis. Eakins could see that Schuessele was going to need help, so he volunteered his services as an unpaid assistant.

The Chess Players. 1875 Oil on wood 11 3/4 x 16 3/4" (29.8 x 42.6 cm)

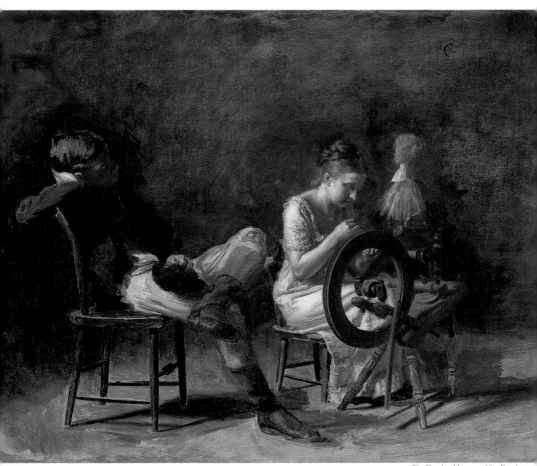

Eakins was cordial to the ailing Schuessele, but abhorred the latter's teaching methods. Tom was convinced that students would be better served by painting nudes than by creating the meticulous copies of antique casts that his older colleague required. (No wonder Eakins's classes were packed!) So in the evenings, when Schuessele went home exhausted, Eakins taught additional life classes. The Academy directors, unhappy to see their professor undermined, instructed Schuessele to attend all classes. Eakins, who had no intention of being anyone's subordinate, decided to teach his classes at the newly formed Art Students' Union.

Poor Schuessele struggled on, but could barely walk by November 1877. One of his students, **Susan Hannah Macdowell (1851–1938)**, wrote to the Academy's Committee on Instruction, asking that Eakins's evening classes be reinstated. Although Macdowell represented the voice of her colleagues in the women's life class, her concern may not have been entirely academic. She had been enamored of Eakins since 1876, when her fascination with *The Gross Clinic* had spurred her resolve to meet the artist. However, Susan was too shy to introduce herself and it was Eakins who made the first move. One day, as Miss Macdowell was leaving Schuessele's class, Eakins, bowing at the waist, asked if he might fasten the button on her glove. "That was it. I fell in love with him right then and there," Susan Macdowell remembered years later. At this juncture, it is difficult to determine whether

OPPOSITE
The Courtship
c. 1878. 20 x 24"
(50.9 x 61 cm)

Anatomical Drawings and Notes. 1878
Pen, ink, and pencil on ruled paper

Eakins was similarly enamored with Miss Macdowell. He offered her private drawing lessons, but maintained his long engagement to Kathrin Crowell.

Ultimately, it was not Macdowell's letter but Schuessele's health problems that prompted the Academy to recall Eakins as his assistant. By 1879, Schuessele was the professor in name only, with Eakins running the school. Because Eakins demanded no money, the Academy directors were able to continue compensating Schuessele, who had no other source of income. This created a win-win situation for both men: Schuessele received a salary while Eakins enjoyed the freedom to revamp the outmoded curriculum and institute the most rigorous course of art instruction available anywhere in the country.

On the cutting edge

Eakins's sweeping innovations diminished the importance of the antique class and placed the emphasis of the Academy's new curriculum where Eakins felt it belonged—on the rigorous study of the human figure. In the life classes, he departed from convention by encouraging his students to put down their charcoal and pick up their brushes. When asked why a student should be allowed to paint before mastering the skills of drawing, Eakins explained that they should learn to "draw with color." He tackled problems with weight and form in the

FYI: Women at the Pennsylvania Academy of the Fine Arts—
In the 19th century, women were denied access to most professional art schools. The Pennsylvania Academy of the Fine Arts was a notable exception. At the time Thomas Eakins began his teaching career at the Academy, about half of the students were female. Although men and women were required to complete the same courses, the life and anatomy classes were segregated. In an era when women dared not show their ankles, and even pianos had skirts to hide their "legs," it was considered improper for a young lady to study the male body. The Academy's directors required male models in the women's life classes to wear a loincloth. In a bizarre attempt to protect the virtue of their female students, the directors even made sure that the corpses in the dissecting room were castrated.

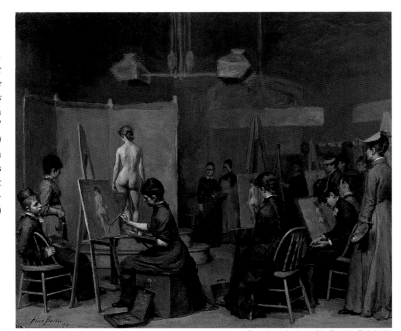

Alice Barber Stephens. *The Women's Life Class* 1879. Oil on cardboard. 12 x 14" (29.4 x 34.3 cm) (Note: Susan Macdowell Eakins is seated in the left foreground, painting the canvas.)

new modeling class and oversaw the teaching of an anatomical training course as demanding and comprehensive as anything offered to the city's medical students.

The honors that evaded Thomas Eakins, painter, came easily to Thomas Eakins, teacher. Although there would never be an article published on his art during his lifetime, *Scribner's Monthly* magazine

interviewed him about his teaching methods shortly after his return to the Academy. The resulting piece was highly favorable and greatly enhanced his reputation as a teacher.

Sound Byte:

"I do not believe that great painting or sculpture or surgery will ever be done by women, yet good enough work is continually done by them to be well worth their doing."

—THOMAS EAKINS, 1886

The Academy Years

The year 1879 began tragically with the death of Kathrin Crowell from meningitis. There is no record of Eakins's reaction to her death. Ironically, now that the necessity of supporting a wife was no longer a consideration, Eakins (now 34) began to make some money for the first time in his life.

Reviews of his paintings continued to be disappointing, but his status as a respected teacher seemed secure. When Christian Schuessele died in August of 1879, the Academy officially appointed Eakins Professor of Drawing and Painting. The position came with a yearly salary of $600—a sum that was soon doubled. More good fortune came his way when Smith College bought a painting for $100 and when one of the Academy's directors, **Fairman Rogers**, offered him a $500 commission.

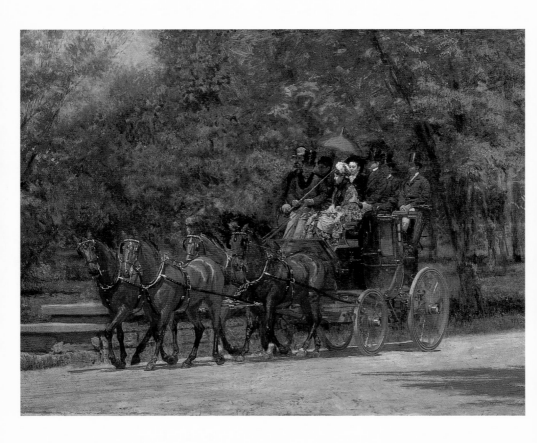

THE FAIRMAN ROGERS FOUR-IN-HAND
OR A MAY MORNING IN THE PARK
1879–80. 23 ¾ x 36" (60.3 x 91.4 cm)

Philadelphia Museum of Art

What: Academy director Fairman Rogers commissioned this canvas of his prized coach and four (i.e., a carriage drawn by four horses). The scene probably commemorated the last leg of a relay race from Philadelphia to New York and back again, sponsored by the Philadelphia Coaching Club on May 6, 1878.

Why: Eakins was fascinated by the photographs of **Eadweard Muybridge** (1830–1904) that unraveled the mysteries of equine locomotion. Horses' legs moved faster than the human eye could follow and, judging by the cave walls at Lascaux, France, artists had been drawing them incorrectly for 15,000 years. Eakins wanted a part in producing the first painting to accurately represent the gait of a trotting horse.

Who: Like most of Eakins's paintings, this one consists of a number of accurate portraits. Fairman Rogers is shown in the driver's seat, with Mrs. Rogers seated next to him. Mrs. Rogers's two siblings and their spouses occupy the seat behind them. The men in the back are grooms. Even the horses are recognizable. Josephine, Rogers's favorite mare, pulls her weight at the left front position.

The Verdict: Although this canvas pulses with strength and life, Eakins seemed unable to win public approval. Muybridge's book *Animal Locomotion* would not be published until 1887, so many critics found the positions of Eakins's horses impossible to accept. Others, who conceded that the gaits might have been scientifically accurate, found the canvas ill-advised. In the words of one reviewer, "The human eye cannot follow the swiftly moving limbs of a horse, and any attempt to arrest them on canvas is a mistake."

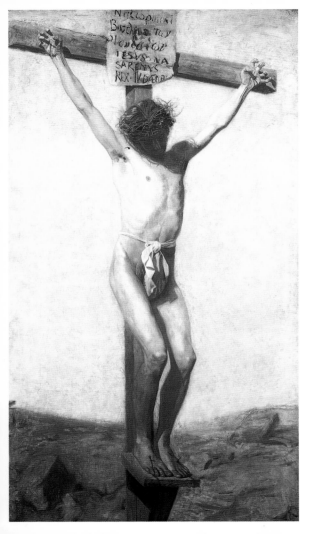

The Crucifixion

Although critics were not kind to the Fairman Rogers painting, Eakins moved on to other works. In 1880, he began his first and only religious painting. Since Eakins was possibly an agnostic and more probably an atheist, it was surprising that he elected to paint the central theme of Christianity: the Crucifixion. He may have felt that his own lack of religious conviction would allow him to be one of the few artists to paint the scene objectively.

Eakins approached the project with his customary attention to detail and accuracy. He constructed a cross, wove a crown of thorns, and asked his 16-year-old student **John Laurie Wallace** (1864–1953), to pose. Eakins and Wallace ferried

across the Delaware River to a secluded spot in the New Jersey woods. There, Eakins dug a hole and planted a cross. He was in the process of photographing the naked Wallace (who was hanging by his hands) when a group of startled hunters emerged from the brush. Artist and model retreated deeper into the woods, where Eakins quickly took the necessary pictures.

After this disconcerting *plein-air* experience, Eakins posed Wallace in the studio and on the roof of the Mount Vernon Street house. Perplexed neighbors worried that the eccentric artist had suspended a corpse from the rafters. Eakins persevered, and the result is a strong depiction of human suffering—a desolate canvas without any of the customary allusions to the impending resurrection. When the painting was exhibited, the reactions again were negative and followed the predictable "precision but no poetry" line that had become the default criticism for Eakins's commitment to naturalism.

The Metropolitan Museum of Art, New York. Gift of Charles Bregler, 1961

ABOVE
Thomas Eakins at age 35 to 40
c. 1879–84

OPPOSITE
The Crucifixion. 1880
96 x 54" (243.8 x 137.2 cm)

Philadelphia Museum of Art. Gift of Mrs. Thomas
Eakins and Miss Mary Adeline Williams

Trudging along

The obstinate, egotistical Eakins refused to be defeated, and in the early 1880s he produced many fine works. He painted John Laurie Wallace again in *Professionals at Rehearsal*, and the love-struck Susan Macdowell became a frequent and exceptionally accommodating model.

RIGHT
Margaret Harrison posing for the painting *The Pathetic Song* with the painting visible at right 1881. Dry-plate negative. 4 x 5" (9.8 x 12.3 cm)

OPPOSITE
The Pathetic Song 1881. 45 x 32 ½" (114.3 x 82.55 cm)

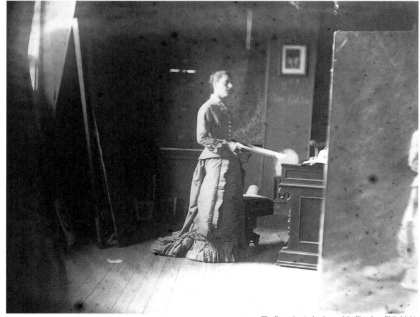

The Pennsylvania Academy of the Fine Arts, Philadelphia

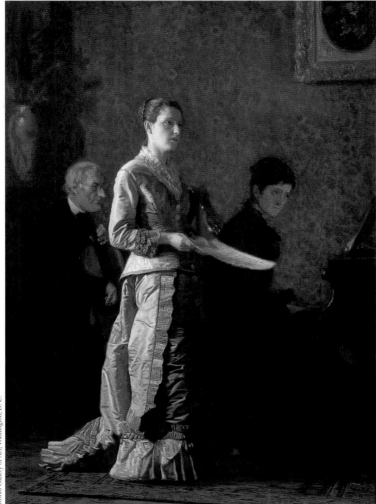

Two photographs taken by Thomas
Eakins around 1883 as studies for his
painting *Arcadia* (see opposite page).
The young boy in the small photograph
(below left) appears as the boy in the
center of *Arcadia*. The standing piper in
the larger photograph (at right) can be
seen on the right side of *Arcadia*.

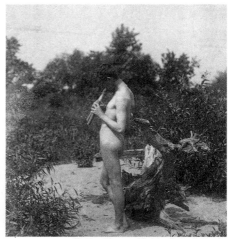

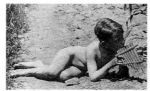

Hirshhorn Museum and Sculpture Garden,
Smithsonian

Hirshhorn Museum and Sculpture Garden, Smithsonian

She appeared as the piano player in *The Pathetic Song* and posed naked
for Eakins's *Arcadian* series: two paintings, a group of oil sketches, some
relief sculptures, and a series of photographs that reveal pastoral land-
scapes peopled with naked or classically draped figures. If Eakins
weren't such a dedicated realist, one could almost imagine a centaur gal-
loping through the trees. At last the controversial Eakins had found a
respectable theme that allowed the inclusion of nude figures. For some
reason, he never completed the series, perhaps because a new commis-
sion intervened.

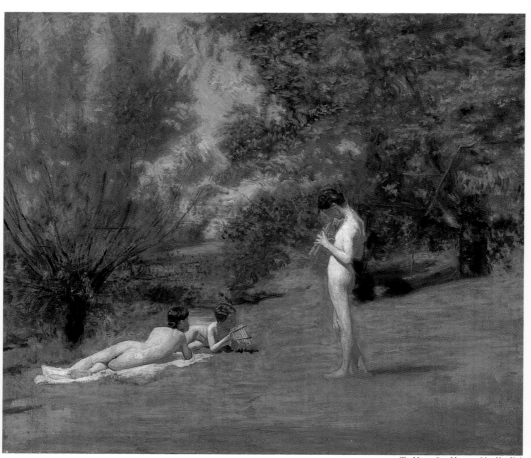

The Writing Master: Portrait of the Artist's Father 1882. 30 x 34 ¼" (76.2 x 87 cm)

By the end of 1883, Eakins felt secure in his position as a leading educator at the most prestigious art school in the country. The Academy had appointed him Director of the Schools as well as Professor of Painting. He taught anatomy twice a week in New York for $100 a month plus expenses. At the age of 39, he could at last afford to move

out of his father's house—a place that now held painful memories. The previous year, Eakins's vigorous, athletic sister Margaret had died suddenly of typhoid fever. It was a tremendous loss for Thomas, who could barely mention her name.

Eakins's sister Frances Eakins Crowell had already broken the home ties and set up housekeeping with her husband and children 35 miles away on a 113-acre farm in Avondale, Pennsylvania. Eakins's other surviving sister, Caddy, would soon marry Eakins's student G. Frank Stephens. That left Tom, who was now ready for a family of his own.

Mrs. Thomas Eakins

Susan ("Susie") Macdowell must have been more than ready herself. She had been waiting for eight years to become Mrs. Thomas Eakins and her patience was rewarded when the couple married on January 19, 1884. The vivacious, joyful 32-year-old Macdowell was the opposite of the intense, moody Eakins. Did he love her? It's hard to say. He certainly had great regard for her artistic ability and called her "the best woman painter in America."

Sound Byte:
"Mrs. Eakins was kinda killed [i.e., professionally] *when she married."*
—CHARLES BREGLER, former student
of Thomas Eakins, c. 1938

Susan Macdowell Eakins with "Dinah." c. 1880 Albumen print 3 ½ x 4 ³/₁₆" (8.6 x 10.3 cm) (Note: Although Thomas and Susan never had children they shared a love for dogs, especially setters.)

Some critics are skeptical about the depth of Eakins's feelings toward his new wife. Biographer William Innes Homer points out that in Eakins's first portrait of Susan, *The Artist's Wife and His Setter Dog*, Tom painted the dog "with more warmth and sympathy than his bride." To be sure, the portrait was a strange creation for a bridegroom. Susan looks haggard and almost anorexic—much older than her years. Despite her husband's possibly ambiguous feelings, Susan Macdowell loved him deeply, and through the travails ahead, she stood by her husband when others would have fled.

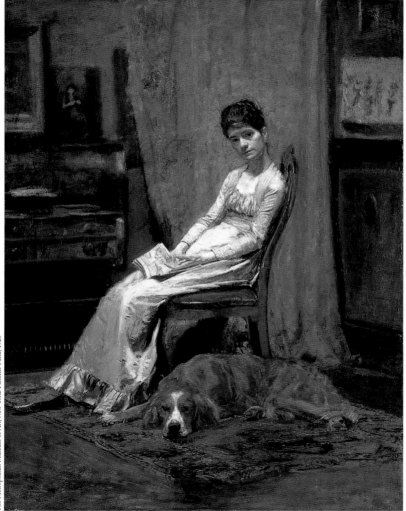

The Artist's Wife and His Setter Dog
c. 1884–88
30 x 23"
(73.5 x 56.4 cm)

The newlyweds moved to a small apartment at 1330 Chestnut Street in Philadelphia. Their rooms were on the top floor and the couple had to do some work to make it livable. Eakins hired a carpenter to install a kitchen and bought cooking supplies, a bed, and some furniture. Tom and Sue laid out their art supplies, and for a time both of them painted. But Susan's career was about to be curtailed, since her husband would require her constant help and support.

FYI: Eakins and Photography—Thomas Eakins's avid interest in motion photography began around 1879 when he first became aware of Eadweard Muybridge's revolutionary photographs of animal locomotion. He honed this interest in 1883 when the famous photographer came to the Academy to lecture. Muybridge's talks were so successful that he was invited to continue his motion studies at the University of Pennsylvania, where Eakins worked with him as a volunteer assistant. Conventional photography was also an important part of Eakins's artistic production. By 1882, he was regularly using photographs as reference materials for many of his paintings. He had begun to take pictures of models and students for his infamous *Naked Series*, a group of photographs that Eakins claimed were taken to assist students in the artistic and scientific investigation of the human body. Biographers speculate that these photographs were intended to illustrate the shifts in weight that occur when a model changes poses.

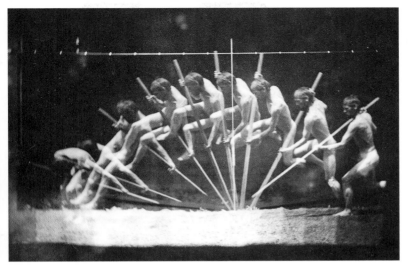

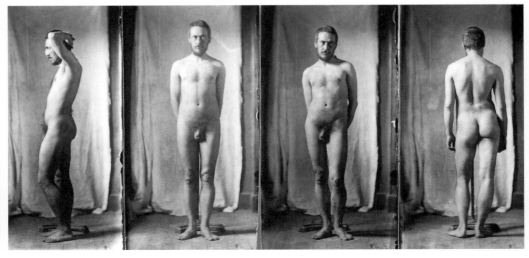

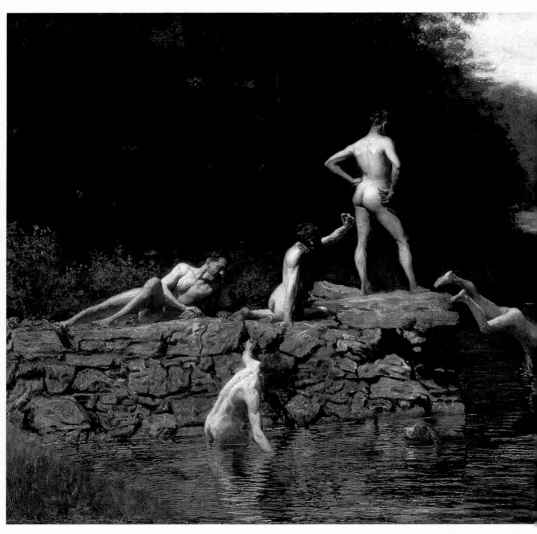

c. 1883–85. 27³⁄₈ x 36³⁄₈" (69.5 x 92.4 cm)

Amon Carter Museum, Fort Worth, Texas

What: In 1884, Edward Hornor Coates, the academy's new chairman of the Committee on Instruction, offered Eakins $800 to create a painting that (it was hoped) could be included in the institution's permanent collection. Eakins completed the work in 1885.

Where: The swimmers enjoy the sunshine at Dove Lake in Bryn Mawr, Pennsylvania, a few miles west of Philadelphia.

Who: Four of the swimmers were Eakins's students. Benjamin Fox is the young man with red hair standing in the water. John Laurie Wallace (who posed for *The Crucifixion*) kneels on the rocks with one arm raised. Jessie Godley stands at the apex of the composition, George Reynolds dives into the water. The older man lying on the rocks is art critic and journalist Talcott Williams and the swimmer is Thomas Eakins. (The dog is Tom's setter, Harry.)

Why: Why did he paint this work? Good question. Eakins must have known that it was risky to paint six recognizable men (four of them either current or past Academy students) cavorting in the nude while their teacher glided up to them like a shark in search of prey. Academy policy forbade students to pose nude in classes, and the idea that Eakins approved of this off-campus activity, then dared to exhibit the evidence in the Academy's annual show, was a direct snub to convention.

The Verdict: When the painting was exhibited, there was very little critical comment. But Eakins's client, Edward Coates, refused to accept the picture and traded it for one of Eakins's less controversial portraits, *The Pathetic Song*.

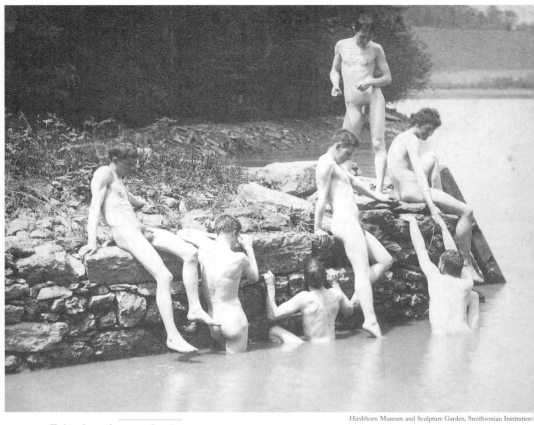

Eakins's students at the site
for *Swimming*. 1883
Albumen print
4 ¾ x 6 ½" (9.3 x 12.2 cm)

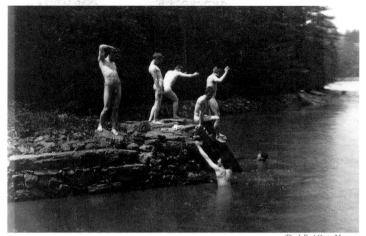

Photograph by
Thomas Eakins
of his students
at the site of
Swimming. 1883
Albumen print
6 $\frac{1}{16}$ x 7 $\frac{13}{16}$"
(14.9 x 18.9 cm)

Eakins in Disgrace

The troubling signs were all there: the naked male students lounging on
the rocks at Dove Lake in happy camaraderie, while the young women
in their long Victorian dresses made a thorough study of the human
body. Eakins must have seen his selection as the Academy's director in
1882 as a vote of confidence for his teaching methods, because after
the appointment he felt invincible and willfully bent or ignored estab-
lished Academy rules set up to protect the integrity of both the stu-
dents and the institution:

- He encouraged both his male and female students to pose nude for
 one another to save on modeling fees, and then he critiqued their
 drawings.

- He asked students to pose naked for his own paintings.

- He posed both his male and female students naked at his home and in the Academy studios for his *Naked Series* collection of photographs.

- He invited female students to impromptu drawing sessions in his home where they posed for one another in the nude.

- On at least one occasion, on the pretext of revealing the movement of the pelvis in relation to the movement of the whole body, he exposed himself to a female student.

Eakins, who had no compunction about removing his clothes, made it his mission to strip his students of any shame they might feel about baring all. To Eakins, the human form was the most beautiful object in nature. Students were not obliged to comply, and some of them did not. But in a school where there was only one professor, and no prizes other than the capital "E" that Eakins inscribed in the margin of a successful painting, the opportunity for abusing his power was obvious.

Sound Byte:
"It seems to me that no one should work in a life class who thinks it wrong to undress if needful."

—THOMAS EAKINS, c. 1886

Exposed and Expelled

Matters came to a head in January 1886 when, in clear defiance of Academy rules, Eakins removed the loincloth from one of the male models in front of a group of female students. Rumors about the incident spread quickly throughout the school and soon reached Edward Coates, the chairman of the Academy's Committee on Instruction. Coates sent Eakins a letter of warning. But once the cat was out of the bag, several students came forward with other grievances, and the Committee on Instruction issued a letter asking for Eakins's resignation. He had little choice but to comply. The dismissal of the Academy's esteemed professor was covered extensively in both the local and national press, and as the alarming allegations surfaced, it became clear that Eakins was not the only one who would suffer in this drama.

At a time when many professional artists' models were prostitutes, any woman who posed in the nude would have her morality called into question if it became known that she had posed naked. So when the identities of Eakins's female models were made public, Eakins claimed that his heart broke for them.

Rock Bottom

It is difficult to know whether Eakins's indiscretions were the premeditated transgressions of a sex offender or if he made mistakes of judg-

ment as a result of an obsessive commitment to the study of the human body. In a series of after-the-fact letters to Coates that ended in March 1886, Eakins assumed the role of the innocent, committed scholar attacked by ignorant enemies with nefarious agendas. Coates seems not to have known what to make of the episode. He wrapped the incriminating *Naked Series* photographs in brown paper, put the bundle in a safe-deposit box, and shut the door on a most unpleasant episode.

Unfortunately, the scandal refused to go away. Because of their association with Eakins, his wife Susan Macdowell Eakins and her sister **Elizabeth Macdowell** (1858–1953), along with their friend **Alice Barber** (1858–1932), were among the women implicated in the scandal. The flames continued to be fanned by a group of Eakins's former friends and students. In their embarrassment, Elizabeth and Alice joined Eakins's accusers, claiming that Eakins had taken advantage of their naïveté. The allegations of the two women caused a rift between the Eakins and Macdowell families that would never completely mend. Susan and her sister remained estranged for several years.

Alice Barber's accusations had even more far-reaching results than Elizabeth's. Barber was engaged to the cousin of **G. Frank Stephens** (1859–1935). (Stephens was the husband of Eakins's sister, Caddy Eakins Stephens.) Caddy launched a damaging attack against her

embattled brother and the falling-out between the two would never heal. The Stephens cousins lobbied for Eakins's expulsion from the Philadelphia Sketch Club for "conduct unworthy of a gentleman and discreditable to this organization." They entered into the evidence accusations of bestiality and incest, allegedly confided to them by Tom's beloved sister Margaret shortly before her death.

Sound Byte:

"I never in my life seduced a girl, nor tried to, but what else can people think of all this rage and insanity?"

—THOMAS EAKINS, 1886

More Trouble

On April 17, 1886, after a review of the complaints, the directors of the Sketch Club found Eakins guilty of the allegations. The specific charges in the Sketch Club case were even more damaging than the indiscretions that had caused Eakins's fall from grace at the Academy.

Poor Susan Eakins rushed to her husband's defense and evidently had some kind of a plan that she decided to abandon on the advice of her brother, **William G. Macdowell** (1845–1926).

Benjamin Eakins
c. 1880–90
Photogravure
5 ¹⁄₂ x 3 ⁹⁄₁₆"
(13.5 x 8.8 cm)
Photographer
unknown

Benjamin Eakins was in agony too. The accusations brought by Caddy Eakins Stephens and her husband Frank (who were still living with Benjamin on Mount Vernon Street) forced him to make a choice between his youngest daughter and his only son. He chose to support Tom, perhaps with the fear that siding with Caddy would require him to admit that he had failed to protect his vulnerable daughters from the perversions of their own brother. Benjamin's eldest daughter, Frances Eakins Crowell, lent credence to her father's position by defending her brother's innocence. Caddy was in the final stages of her first pregnancy, but as soon as the baby was born, she and her husband were asked to leave. Thomas and Sue, who without the teaching salary were living on a much-reduced income, moved back in with Benjamin, although they maintained the apartment on Chestnut Street as a studio.

Three years after the scandal, Caddy Stephens died of typhoid fever.

A Vote for Tom

Throughout the "trouble" at the Academy, loyal friends and supporters did their best to defend Thomas Eakins:

- Following his ouster, a group of male students signed a petition demanding that Eakins be reinstated.

- After delivering the petition, each young man fastened a large "E" (for "Eakins") to his hat and, in a torchlight parade, marched to Eakins's studio, where they shouted for their instructor to make an appearance. Eakins stayed inside.

- The following day, the women students wrote a similar petition. All but a dozen signed it.

- On Feburary 22, 1886, sixteen of Eakins's loyal male students withdrew from the Academy and formed the Art Students' League of Philadelphia. Eakins agreed to be their unpaid instructor.

Exile

For the next year, Eakins painted very little. He preferred to focus his energies on the fledgling Art Students' League, hoping it might one day pose a serious challenge to the preeminence of the Academy. Since he was no longer under the thumb of the bureaucrats and administrators he had detested since his student days in Paris, Eakins felt free to do as he pleased.

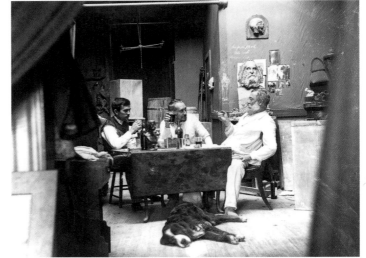

Samuel Murray
Thomas Eakins
and William R.
O'Donovan in
Chestnut Street
Studio. 1891–92
Attributed to
Susan Macdowell
Eakins

Eakins, who never had children of his own, took a personal, paternal interest in his all-male class and called his students "the boys." They called him "The Boss." In the fall of 1886, 17-year-old **Samuel Murray** (1869–1941) joined the classes at the Art Students' League. Despite the difference in their ages, Murray became Eakins's favorite student and most trusted friend.

Sound Byte:
"There is too much of this common, ordinary work. Respectability in art is appalling."

—Thomas Eakins, remarks to
his students, c. 1885

Home on the Range

A year later, Eakins's emotional wounds had still not healed. So in the summer of 1887 he made plans to take a restorative journey to the wilds of the Dakota Territory, where he would stay at a friend's ranch, do a little painting, and generally pull himself together. He may have had another reason for making his escape. Former Academy student **Lilian Hammitt** (1865–?) began corresponding with Eakins and asking his advice on personal matters. These inquiries worried Susan, who instinctively sensed danger. While Tom was off on his cowboy escapade, Susan assiduously answered Lilian's letters.

Eakins rode horses, went on a roundup, killed a rattlesnake, and reported his adventures to Susan like a child writing home from summer camp. He took photographs and made a few sketches. In October 1887, he returned home on a cattle train, bringing two horses with him—a white bronco for Susan and an Indian pony for his sister Frances's children. The eastbound train let him off near the Crowell farm in Avondale, where Benjamin Eakins met him. Father and son traveled the final leg of the journey together, and his delighted nieces and nephews greeted their Uncle Tom as a conquering hero. He enchanted the Crowell boys with his western souvenirs—a complete cowboy outfit and three guns. He brought his oldest niece, **Ella,** a trophy—the rattle from the snake he had killed.

Eakins left the horses behind on the Crowell farm, and their presence gave Eakins an excuse to visit often. He adored the children (there were eventually ten of them) and their affection for him seemed to renew his spirit. He took up his brushes and began to paint again.

Sound Byte:

"The average man is a nincompoop."

—THOMAS EAKINS

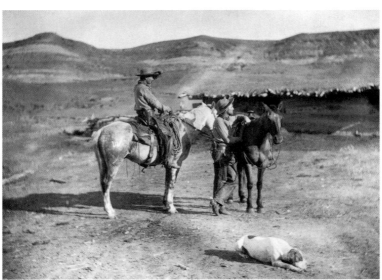

The Pennsylvania Academy of Fine Arts, Philadelphia. Charles Bregler's Thomas Eakins Collection, purchased with the partial support of the Pew Memorial Trust

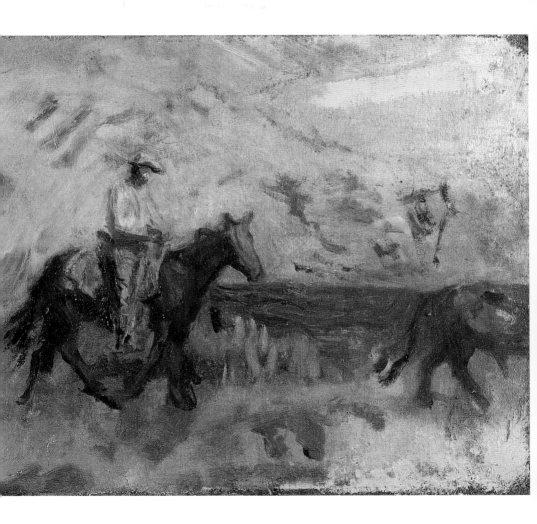

Walt Whitman

Eakins's commitment to the frank and unrestrained study of human physiology eventually led him across the Delaware River to the home of poet **Walt Whitman** (1819–1892). Talcott Williams (the reclining figure in *Swimmers*) had first introduced Eakins to Whitman in the spring of 1887, and the poet and the painter found that they had much in common. Eakins must have appreciated verses from Whitman's landmark volume of poetry, *Leaves of Grass,* such as, "If anything is sacred, the human body is sacred."

Eakins admired Whitman's ability to persist in his work despite public censure. (*Leaves of Grass* had been vilified as "reckless" and "indecent.") By the time Eakins came to know him, the great poet was writing with explicit honesty about subjects that were usually off limits in polite society.

One day, Eakins turned up on the poet's doorstep with a blank canvas under his arm and by April 1888 had finished his portrait of Whitman. It is a beautiful, expressive painting and the first canvas he had completed in two years. Whitman liked the work very much.

ABOVE
Walt Whitman
seated on a fur
robe. c. 1891
3 3/4 x 4 3/4"
(9.2 x 11.7 cm)

OPPOSITE
Walt Whitman
1888. 30 1/8 x 24 1/4"
(76.5 x 61.6 cm)

Pennsylvania Academy of the
Fine Arts, Philadelphia

Sound Byte:

"Of all portraits of me made by artists I like Eakins's best: it is not perfect but it comes nearest being me."

—WALT WHITMAN, c. 1888

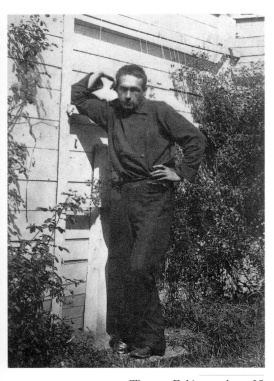

Thomas Eakins at about 35
in the garden of his home
c. 1876–79

Eakins and his friend Samuel Murray paid many visits to Whitman during the poet's remaining years, and Eakins was one of 32 friends invited to his 72nd birthday. The day after Whitman's death on March 26, 1892, Eakins and Murray made death masks of his face, shoulders, and right hand. At the funeral, Eakins was a pallbearer.

The Gay factor

Whitman's poetry reveals the poet's ease with his homosexuality, and the friendship between Eakins and Whitman along with the enduring relationship between Eakins and Murray, and the nude photographs of Eakins's male students, have all raised questions about Eakins's sexuality. Was he homosexual? It's impossible to know for sure. But there's no question that several of Eakins's male students—who referred to themselves as "us Whitman fellows"—were bound together by something more than platonic friendship.

Eakins's dealings with his female students were equally mysterious. Before completing the Whitman portrait, he began work on an ill-advised portrait of Lilian Hammitt but abandoned it in March 1888 when Lilian wrote him a bizarre letter in which she discussed just how the two of them would handle his impending divorce and their upcoming marriage.

Like everything else about Eakins's private life, this incident is open to interpretation. Did Eakins have sexual relations with Lilian Hammitt as she later alleged? Women who posed for Eakins's portraits claimed that he loved to shock them with coarse jokes and that he often asked them to pose in the nude. When they refused, he would alternately badger and cajole them until they either impressed him with their resolve to resist his advances or fled.

Lovelorn Lilian

Eakins told Lilian that he was not about to divorce his wife, and when Lilian's emotional state deteriorated, she was committed to a mental hospital. Following her release, Philadelphia police found her on the street dressed in nothing but her bathing suit. They were surprised to hear her identify herself as Mrs. Thomas Eakins and discuss her sexual relationship with the artist. The incident made it into the newspapers, which further embarrassed the long-suffering Susan and added to Tom's dicey reputation.

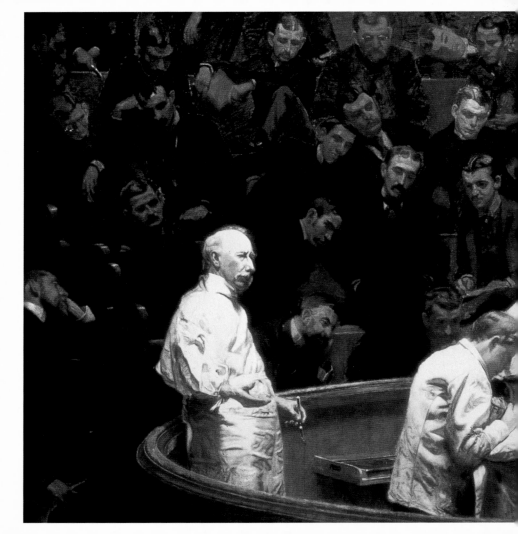

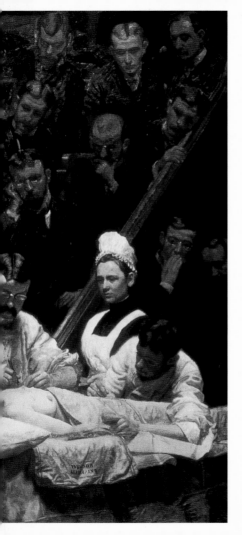

THE AGNEW CLINIC
1889. 74½ x 130½" (189.2 x 331.5 cm)

University of Pennsylvania Art Collection, Philadelphia

What: When the medical students at the University of Pennsylvania commissioned Thomas Eakins to paint a picture to commemorate the retirement of Dr. D. Hayes Agnew, they envisioned a simple portrait. Eakins, who badly needed to salvage his reputation, conceived something grander. The monumental canvas depicts Dr. Agnew in the operating theater as he completes a mastectomy on a young female patient.

Who: Dr. Agnew, scalpel in hand, is at the center of this complex composition. Two doctors assist the great surgeon, along with an anesthesiologist and a nurse. Eakins integrated 27 portraits into the composition, including the medical students who had commissioned the painting and Dr. Fred H. Milliken, who stands in the entrance, whispering to the artist, Thomas Eakins.

How: Eakins observed many of Agnew's operations, and the doctor came to Eakins's studio on several occasions to pose. The other members of the cast also sat for their portraits at the studio, where Eakins built risers to accommodate them. Because the canvas was so large (about 6' x 11'), Eakins had to sit on the floor to paint the lower half.

Fun Fact: Thomas Eakins was not the only artist who worked on this canvas. Susan Macdowell Eakins painted the portrait of her husband.

A Big Opportunity

The worst was yet to come, but by this stage in his life Eakins seems to have gained the strength, if not wisdom, to weather any storm. In 1889, he received his first commission since the Academy scandal. The medical students at the University of Pennsylvania's School of Medicine had raised $750 for a portrait of Dr. D. Hayes Agnew, who was about to retire from the faculty. Eakins had everything at stake here. After three years in purgatory, here at last was his chance to reestablish his reputation. So, although he had only three months to complete the project, Eakins embarked on his largest and most ambitious canvas.

Eakins completed *The Agnew Clinic* in advance of the deadline and exhibited it at Philadelphia's Haseltine Gallery before it was presented to the university. Because it was on display only briefly, there was little public comment, but those who saw the canvas were shocked by the subject matter. Once again, Eakins had courted controversy by choosing to show Dr. Agnew—whose expertise lay in treating gunshot wounds—performing a mastectomy. After all he had been through, Eakins's surprise at the reaction to his painting seemed unusually naïve—yet with tears in his eyes he confided to a friend, "They call me a butcher, and all I was trying to do was to picture the soul of a great surgeon."

About the Nieces

While Eakins was attempting to reestablish his reputation as a painter, he was also working hard to regain his position as an educator. He was teaching anatomy in New York City, but his own Art Students' League was beleaguered. Enrollment had never reached the levels necessary to make the enterprise successful, and the school had no financial backers. Yet, Eakins had his steadfast supporters, two of whom were his sister Frances and her husband, William Crowell. In a show of confidence, they allowed their two eldest daughters to come to Philadelphia

The Metropolitan Museum of Art, New York. Gift of Joan and Martin E. Messinger, 1985

Margaret Eakins, Ella Crowell, and Frances Eakins Crowell in the yard at Mount Vernon Street, Philadelphia. c. 1890
Albumen silver print
3 ³⁄₅ x 4 ³⁄₅" (8.9 x 11.5 cm)

OPPOSITE
The Concert Singer
1890–92
75 ¹/₈ x 54 ¹/₄"
(190.8 x 137.8 cm)

and study at the Art Students' League. Although the Crowells defended Eakins's commitment to the unabashed study of the nude during his troubles at the Academy, their opinions concerning their daughters Ella, 15, and **Maggie**, 13, were more conservative. The girls had enthusiastically lobbied for the opportunity to study art and were eventually given permission to live at their grandfather's house and attend classes at the League. Frances reminded Tom in a letter that her daughters were innocent; she requested that they not be allowed to pose in the nude.

Two days after their arrival, Eakins wrote to Frances, informing her that although the girls would receive the best of care, they would also be afforded the opportunity to observe the naked human body. The girls might pose for each other, he informed his sister, or draw from the nude model, or "see any time any part of my body or Susie's, or any professional or private model."

Sound Byte:
"I thought you had given up girl students posing. Surely your experience with it was hard, and cost you dear. Think how it broke up two families, how we lost Caddy through it, the misery it cost Papa and all of us, yourself and Susie included."

—FRANCES EAKINS CROWELL
to her brother, Thomas, 1890

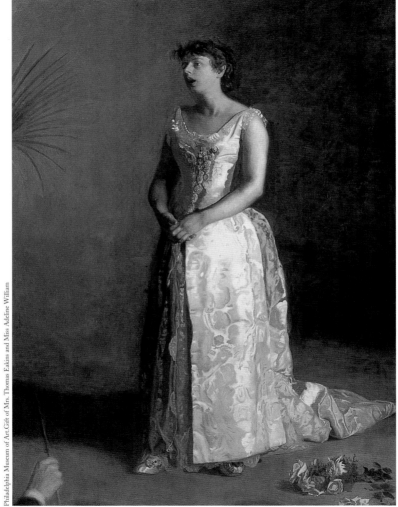

The Crowell sisters studied at Eakins's school for several years, apparently without incident. When the Art Students' League finally dissolved in 1893, the girls were permitted to study privately with their uncle, even though his teaching methods continued to come under fire.

In 1894, Eakins was reprimanded at the National Academy in New York (and later dismissed) for instructing a male model to disrobe in front of a mixed class. In 1895, he was discharged from a newly formed anatomy class at Philadelphia's Drexel Institute for the same "offense."

The niece's apprenticeship ended in 1895, when Eakins told his sister that he was about to embark on a project that would involve extensive study of the nude. Under the circumstances, it would be inappropriate for the girls to frequent the studio. Both young women continued to live at their grandfather's house, but Ella, whose interest in art was waning, entered nursing school and Maggie enrolled in classes at the Pennsylvania Academy of the Fine Arts.

Ella unravels

Shortly after entering the nursing program, Ella began to fall apart. She inadvertently administered an overdose of medicine to a patient and, though the patient recovered, Ella did not. She threatened to shoot herself, a friend, and her uncle, but instead swallowed the same medication that almost killed her patient. Her distraught parents committed her to a mental hospital and immediately accusations began to fly between the Eakins and Crowell families.

Frances accused Thomas of seducing Ella, and both girls sustained the charges. Ella told her mother that Eakins had forced her to touch his "private parts." Maggie Crowell informed classmates at the Academy that Ella's insanity was the result of abuse by her uncle—"unnatural sexual excitements practiced upon her in the style of Oscar Wilde." Was Maggie accusing her uncle of sodomy? The sensational trial of Irish playwright, poet, and novelist **Oscar Wilde** (1854–1900) on charges of homosexuality was front-page news in 1895, but Maggie may not have understood the exact implications of her allegations. Ella was released from the hospital after several months of treatment and returned to her parents' farm.

Pennsylvania Academy of the Fine Arts, Philadelphia·

The Cello Player. 1896
64 ⅛ x 48 ¼"
(162.9 x 122.6 cm)

Death by Gunshot

On July 2, 1897, the 24-year-old Ella Crowell picked up a gun and ended her life. Her suicide devastated the Eakins family. Thomas was never allowed back on his sister's farm and the nine remaining Crowell children were forbidden to mention his name. Susan staunchly defended her husband's innocence in a coldly factual and strikingly critical memorandum devoid of any spark of sympathy for her dead niece. There is no record of Ben-

ABOVE
Between Rounds. 1899
50 ⅛ x 39 ⅞" (127.3 x 101.3 cm)

OPPOSITE
Salutat. 1898. 50 x 40"
(127.0 x 101.5 cm)

jamin Eakins's reaction to this latest tragedy. Thomas Eakins himself was silent, but within a year he had quit teaching altogether and, although only 53 years old, he would never again return to the classroom.

New Alliances

The estrangement from his family pulled Eakins closer to his former student and most intimate friend, Samuel Murray. The taint of Eakins's reputation had not contaminated Murray's career. By 1897, Murray—who was only 28— was a successful sculptor, a respected teacher at the Philadelphia School of Design for Women, and the recipient of a new $3,000 commission to sculpt ten monumental statues of biblical prophets for the Witherspoon building in Philadelphia.

In the year following Ella Crowell's death, Murray seemed determined to keep Thomas occupied. By day, the two friends collaborated on the Witherspoon job, and in the evenings they went out on the town. Murray was a boxing fan and

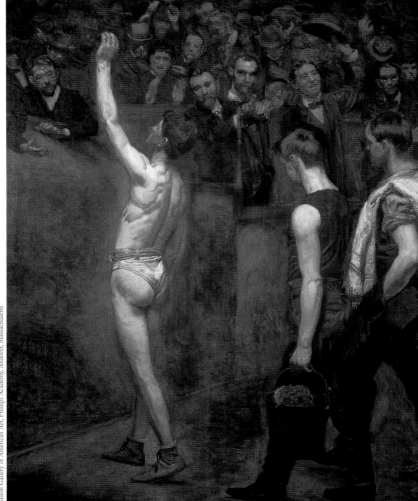

Eakins, captivated by the barely clad fighters, soon shared his passion. The charged atmosphere of the arena inspired Eakins's final series of paintings of athletes. These complex canvases tested Eakins's knowledge of anatomy and perspective and demanded his full concentration. Two of the paintings, *Between Rounds* and *Salutat*, rank among the artist's best. He exhibited them both. But as the decade ended, the 55-year-old painter who once caused such a stir with his shockingly realistic work and his much-publicized teaching methods was largely ignored.

On His Own

Benjamin Eakins died on December 30, 1899, two days before the world rang in a new century. The old gentleman had made arrangements to bequeath his $90,000 estate equally to Frances, Thomas, and the children of his youngest daughter, Caddy. The house on Mount Vernon Street went to Thomas, so he inherited approximately $22,500, enough to provide a modest income at the time.

With privacy no longer an issue, Eakins moved his studio back home. He invited his childhood friend **Mary Adeline (Addie) Williams** (1853–1941) to join the family and painted her portrait, in addition to the one he painted of Susan. His wife, gray-haired in a black coat, looks old and worn in her portrait—close to tears. In contrast, Addie—who

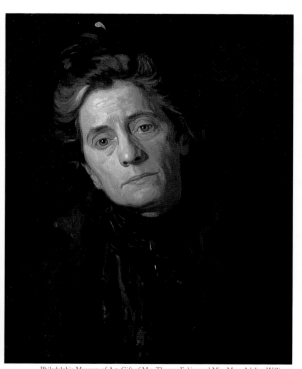

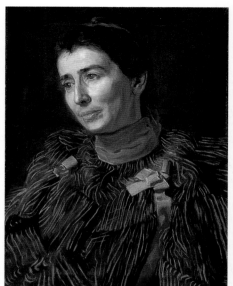

ABOVE LEFT
Mrs. Thomas Eakins. c. 1899. 20 ⅛ x 16 ⅛" (51.0 x 40.8 cm)

ABOVE RIGHT
Portrait of Mary Adeline (Addie) Williams. c. 1900
24 ⅛ x 18 ⅛" (61.3 x 46 cm)

was two years younger than Susan—looks pleasant in ruffles and pink bows. It's anyone's guess what's going on in this odd painting. Susan Eakins called Addie "a beloved companion in our house." Others speculated about a ménage à trois, but perhaps Susan's words can be taken

OPPOSITE
Self-Portrait. 1902
30 x 25"
(76.2 x 63.5 cm)

FYI: Ménage à trois?—Eakins's biographer Lloyd Goodrich wrote that the idea of a ménage à trois involving Eakins, his wife, and Addie Williams had been taken for granted by one relative he interviewed in 1933: "You know, of course, that Uncle Tom made love to Addie Williams." But when Goodrich spoke with another couple friendly with the Eakinses, and the husband mentioned a ménage à trois, his wife quickly corrected him and said, "You don't actually know that it was a ménage à trois." Goodrich did not believe Eakins had had an affair with Williams or anyone else, citing the artist's "seriousness, dedication to work, scorn of 'silliness,' and incapacity for the customary idealization and illusion." However, much of the information for Goodrich's monograph (published in 1933 and revised and expanded in 1982) came from Susan Eakins, who evidently was not forthcoming with all the correspondence relating to the scandals that plagued her husband's career. These letters became the property of **Charles Bregler,** a former student of Eakins who salvaged them after Susan Eakins died. When Bregler died in 1958, the Eakins material stayed with his wife, who lent the collection to the PAFA (after years of inquiries) in 1984. The papers were acquired by the PAFA in 1985.

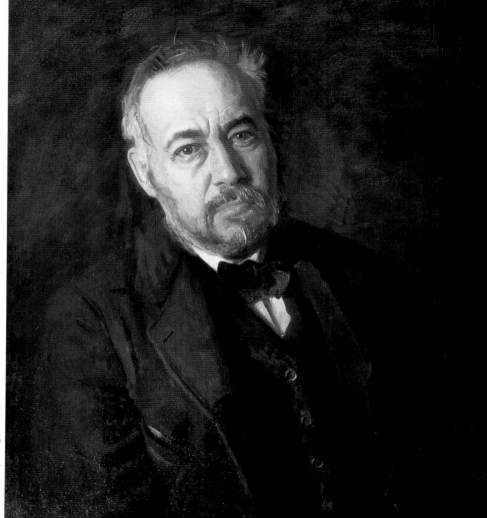

at their face value. With her husband so often occupied by Samuel Murray, maybe she needed a friend.

Too little too late

By the turn of the century, Eakins's worst troubles were over. Although he never compromised his style, there were no further scandals, and between 1902 and 1905 he created a steady stream of portraits, including ten commissions. Each likeness was a starkly realistic, accurate representation of the person posing. However, in the new century, Victorian sentiment no longer defined what was acceptable in art, and Eakins's work began to attract some well-deserved recognition:

■ In 1901, Eakins won a gold medal at the Pan-American Exposition in Buffalo and was asked to serve on the jury of the annual exhibition of the Pennsylvania Academy of the Fine Arts for the first time since 1879.

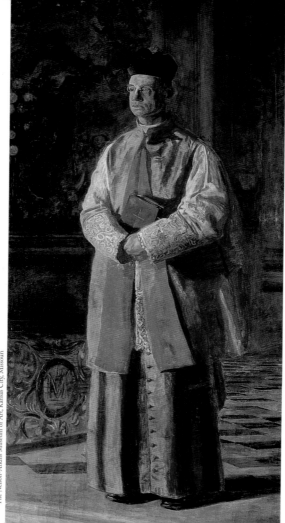

*Portrait of
Monsignor
James P. Turner*
c. 1906. 88 x 42"
(223.5 x 105.7 cm)

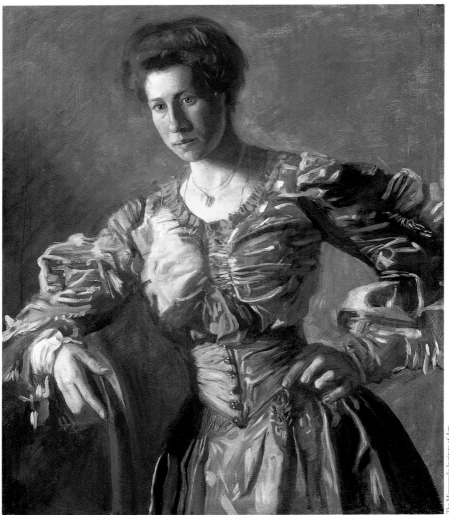

- In 1902, Eakins was elected first as an Associate of the National Academy of Design, New York, and, three months later, as a full academician.

- In 1904, he was awarded the Pennsylvania Academy's Temple Gold Medal and a gold medal at the Universal Exposition in St. Louis.

- In 1905, he received the Thomas R. Proctor Prize from the National Academy of Design.

- 1907 brought a gold medal from Philadelphia's American Art Society.

However, these were modest successes compared to the honors received by his contemporaries, and they came too late to make any real difference in Eakins's life. By the time of these awards, Eakins was already a bitter man. In spite of the increase in his commissions during the 13 years between 1897 and 1910, there are no recorded sales of Eakins's paintings.

Characteristically, he said little about his disappointing career. Instead, he painted one final canvas that recorded his frustration. In 1908, after a 30-year hiatus, he revisited the theme of the sculptor, William Rush and his model. This time the canvas was more autobiographical. He

OPPOSITE
Portrait of
Elizabeth
L. Burton. 1905–06
30 x 25"
(76.2 x 63.5 cm)

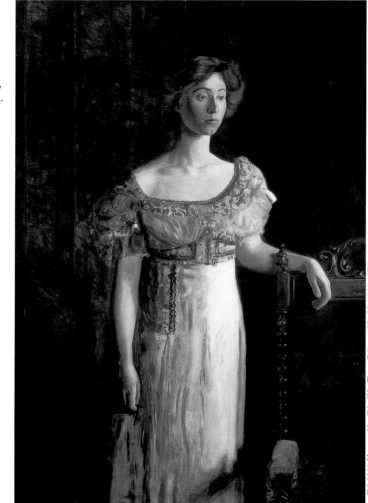

The Old–Fashioned Dress (Portrait of Helen Parker)
c. 1908
60 1/8 x 40 3/16"
(152.7 x 102.1 cm)

stripped all elegance from the scene, depicting instead a dusty workshop where the sculptor confronts a naked model.

Eakins was not satisfied with the canvas and began again. In the revised version, the sculptor takes the model's hand and helps her down from the model stand. (Notice that Rush bears a strong resemblance to Eakins.) Since the naked girl faces the viewer, Eakins was forced to deal with the one taboo he had never confronted in his paintings: pubic hair. In the 19th and early 20th centuries, the idealized female form never showed pubic hair. Eakins had preached realism all his life and was not about to avoid the obvious. He rendered the picture accurately but never finished it. Perhaps he was too tired to take on one last crusade.

Sound Byte:
"He was a silent man, not sad exactly, but disappointed—he had had blows. There was sadness underneath; he had not been able to do what he wanted to do."

—SUSAN MACDOWELL EAKINS,
recalling her husband, c. 1930

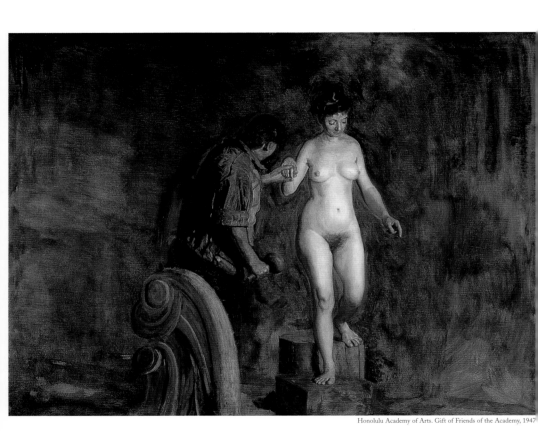

The End draws near

By 1910, the 67-year-old Eakins was in declining health. The nature of his illness is not known, although everything from kidney trouble to formaldehyde poisoning has been mentioned. He spent most of his time in his studio surrounded by a lifetime of unsold canvases. Visitors reported that he had to be helped around and that he often fell asleep during conversations. Eakins's hopes of ever selling his canvases were so shattered that when someone admired a painting, he offered it as a gift—or, if pressed for a price, he quoted $100.

Although Eakins was weak, Murray encouraged him to exhibit his work. In 1914, the artist sent a portrait study for the *Agnew Clinic* to the annual exhibit at the Pennsylvania Academy, and in a last act of defiance to the critics, the public, and the Academy, priced the canvas at $4,000.

The picture created a sensation. The *Philadelphia Inquirer* exuded, "This massive and powerful portrait, done by the master at the very height of his career, will one day be amongst the most treasured possessions of some great American museum. It compares with the masterpieces of all time." The painting was sold to the famous collector Dr. Albert C. Barnes, whose paintings would eventually form the Barnes Collection, in Merion, Pennsylvania. Greatly encouraged, Eakins

OPPOSITE
*William Rush
and His Model*
1907–8
35 $\frac{1}{4}$ x 47 $\frac{1}{4}$"
(89.5 x 120.0 cm)

raised the prices on all his paintings, but once the excitement of the Agnew triumph was forgotten, he found few buyers.

The Eakins Legacy

Thomas Cowperthwait Eakins died on June 25, 1916, at his home on Mount Vernon Street, attended by the three people he loved the most: Susan Macdowell Eakins, Samuel Murray, and Addie Williams. Susan Eakins tried to arrange a memorial exhibition at the Pennsylvania Academy, but when this proved unsuccessful she turned her attention to New York's Metropolitan Museum of Art, whose curator of paintings, **Bryson Burroughs** (1869–1934), organized a show.

Although Burroughs admired Eakins's work, he feared that the artist was so little known that the exhibition would be ignored. He asked for letters of support from Eakins's more successful contemporaries, painters John Singer Sargent, **Cecilia Beaux** (1855–1942), **Kenyon Cox** (1856–1919), and **Robert Henri** (1865–1929). The response was polite but

Thomas Eakins at about 65
c. 1910. Platinum print
by Conrad F. Haeseler
6 1/16 x 4" (14.95 x 9.8 cm)

guarded. The exhibition opened on November 5, 1917, to critical acclaim and public apathy. Ironically, the Eakins paintings that had shocked the 19th-century public seemed like old news to 20th-century New Yorkers. Since the public had been introduced to such artists as **Vincent van Gogh** (1853–1890), **Paul Gauguin** (1848–1903), **Paul Cézanne** (1839–1906), and the wonderfully outrageous **Marcel Duchamp** (1887–1968), they considered Eakins's finely crafted portraits and landscapes outdated and dull.

Sound Byte:

"Thomas Eakins was a man of great character. He was a man of iron will and his will was to paint and to carry out his life as he thought it should go. This he did. It cost him heavily, but in his works we have the precious result of his independence, his generous heart and big mind."

—ROBERT HENRI,
American artist, 1917

Susan Macdowell Eakins died in 1938, without having seen her husband vindicated. Although the value of Eakins's work would gradually increase, his paintings would not be recognized as American masterpieces until the 1970s, when his canvases brought record prices at auction and were finally awarded their proper place in the canon of

Susan Macdowell
Eakins
March 3, 1938
(eight months
before her death)
Photograph by
Carl van Vechten
Gelatin print
7 ½ x 9 ¹⁵/₁₆"
(18.4 x 24.7 cm)

American art. Although Eakins's brilliant technical facility and unique personal vision were first ignored by critics anxious to defend the art establishment and were later maligned by a generation of reviewers eager to embrace artistic innovation, time eventually corrected their bias. Today, the sound and the fury that surrounded Thomas Eakins is forgotten and his legacy is just what he would have hoped for had he dared to hope in those final years: a priceless heritage of luminous canvases celebrated for their uncompromising honesty, skill, originality, and beauty.